Screencasting for Libraries

Greg R. Notess

ALA TechSource

An imprint of the American Library Association

Chicago 2012

Printed in the United States of America

Library of Congress Cataloging-in-Publication Data
Notess, Greg R.
 Screencasting for libraries / Greg R. Notess.
 p. cm. — (The tech set ; #17)
 Includes bibliographical references and index.
 ISBN 978-1-55570-786-6 (alk. paper)
 1. Libraries and video recording. 2. Library orientation—Computer-assisted instruction. 3. Webcasting. I. Title.

Z716.85.N68 2012
006.7'876—dc23

 2012007203

⊚ This paper meets the requirements of ANSI/NISO Z39.48-1992 (Permanence of Paper).

CONTENTS

Don't miss this book's companion website!

Turn the page for details.

**THE TECH SET® Volumes 11–20 is more than just the book
you're holding!**

These 10 titles, along with the 10 titles that preceded them, in THE TECH SET® series feature three components:

1. This book
2. Companion web content that provides more details on the topic and keeps you current
3. Author podcasts that will extend your knowledge and give you insight into the author's experience

The companion webpages and podcasts can be found at:

www.alatechsource.org/techset/

On the website, you'll go far beyond the printed pages you're holding and:

- ▶ Access author updates that are packed with new advice and recommended resources
- ▶ Use the website comments section to interact, ask questions, and share advice with the authors and your LIS peers
- ▶ Hear these pros in screencasts, podcasts, and other videos providing great instruction on getting the most out of the latest library technologies

For more information on THE TECH SET® series and the individual titles, visit **www.neal-schuman.com/techset-11-to-20**.

▶

FOREWORD

Screencasts are short instructional videos that demonstrate computer-related tasks and can be a very effective way to show library patrons how to use your website, OPAC, or databases. *Screencasting for Libraries* is a complete how-to guidebook that provides tips and techniques for how to create engaging library training screencasts and store them on the web. From planning and software selection to storyboarding, scripting, and distribution, this practical primer provides step-by-step instructions. In this top-notch handbook, screencaster extraordinaire Greg Notess explains how to edit timelines, add callouts and quizzes, and insert audio tracks. Everything from planning a click path to using advanced features such as picture-in-picture and captioning for the hearing impaired is outlined. The author is mindful of library budgets and provides both free and fee software options in this outstanding guide.

The ten new TECH SET volumes are designed to be even more cutting-edge than the original ten. After the first ten were published and we received such positive feedback from librarians who were using the books to implement technology in their libraries as well as train their staff, it seemed that there would be a need for another TECH SET. And I wanted this next set of books to be even more forward-looking and tackle today's hottest technologies, trends, and practices to help libraries stay on the forefront of technology innovation. Librarians have ceased sitting on the sidelines and have become technology leaders in their own right. This series was created to offer guidance and inspiration to all those aspiring to be library technology leaders themselves.

I originally envisioned a series of books that would offer accessible, practical information that would teach librarians not only how to use new technologies as individuals but also how to plan and implement particular types of library services using them. And when THE TECH SET won the ALA's Greenwood Publishing Group Award for the Best Book in Library Literature, it seemed that we had achieved our goal of becoming the go-to resource for libraries

wanting hands-on technology primers. For these new ten books, I thought it was important to incorporate reader feedback by adding two new chapters to each volume that would better facilitate learning how to put these new technologies into practice in libraries. The new chapter called "Social Mechanics" discusses strategies for gaining buy-in and support from organizational stakeholders, and the additional "Developing Trends" chapter looks ahead to future directions of these technologies. These new chapters round out the books that discuss the entire life cycle of these tech initiatives, including everything from what it takes to plan, strategize, implement, market, and measure the success of these projects.

While each book covers the A–Zs of the technology being discussed, the hands-on "Implementation" chapters, chock-full of detailed project instructions, account for the largest portions of the books. These chapters start off with a basic "recipe" for how to effectively use the technology in a library and then build on that foundation to offer more and more advanced project ideas. Because these books are designed to appeal to readers of all levels of expertise, both the novice and advanced technologist will find something useful in these chapters, as the proposed projects and initiatives run the gamut from the basic how to create a Foursquare campaign for your library to how to build an iPhone application. Similarly, the new Drupal webmaster will benefit from the instructions for how to configure a basic library website, while the advanced web services librarian may be interested in the instructions for powering a dynamic library website in the cloud using Amazon's EC2 service.

I have had the pleasure of hearing Greg Notess present about creating online tutorials and screencasts at several library conferences and have always been engaged and inspired. I knew that he would be the perfect choice to write *Screencasting for Libraries*, and he didn't disappoint. In fact, he exceeded my expectations for this title. Greg created screencast prototypes for each project in the "Implementation" chapter and made them available for readers to watch and learn from on the companion website (http://www .alatechsource.org/techset/). His years of experience and extensive knowledge are evident in this go-to resource for developing screencasts in libraries.

Ellyssa Kroski
Manager of Information Systems
New York Law Institute
http://www.ellyssakroski.com/
http://oedb.org/blogs/ilibrarian/
ellyssakroski@yahoo.com

Ellyssa Kroski is the Manager of Information Systems at the New York Law Institute as well as a writer, educator, and international conference speaker. In 2011, she won the ALA's Greenwood Publishing Group Award for the Best Book in Library Literature for THE TECH SET, the ten-book technology series that she created and edited. She's also the author of *Web 2.0 for Librarians and Information Professionals*, a well-reviewed book on web technologies and libraries. She speaks at several conferences a year, mainly about new tech trends, digital strategy, and libraries. She is an adjunct faculty member at Pratt Institute and blogs at *iLibrarian*.

PREFACE

Screencasting for Libraries teaches the basics of screencasting. From freely available online resources to commercial market leaders, the book explores software options that can fit into any library budget. It shows you how to host screencasts on your own library website, embed them in your blog, or host them in the cloud on YouTube, Screencast.com, or elsewhere. Librarians, information technology workers, educators, and students can all benefit from knowing basic screencasting techniques. Reference librarians can create screencasts for individual phone, e-mail, and virtual reference transactions. Instruction librarians can create all kinds of short instructional tutorials. Online guide creators can embed screencasts right next to links and textual help for databases. Bloggers can embed screencasts, and Twitterers can easily link to them.

Screencasting and the online video space have become so popular that there are far more options than can be explored in this short book. Instead, *Screencasting for Libraries* highlights the best practices for quickly getting started with screencasting, featuring some of the best current choices. Anyone trying to demonstrate how to use computer software, navigate online search engines, or troubleshoot Internet or computer issues can profit from having a screencasting toolbox readily available. If you're teaching a class, for example, you can record your PowerPoint and voice into a long screencast for students to review (or for those who miss the class).

▶ ORGANIZATION AND AUDIENCE

Screencasting for Libraries comes from years of practice and presentations at many screencasting workshops, often focused on how to create and publish screencasts with minimal effort. The book is organized to provide crucial information on screencasting from step one to the final stages. Chapter 1 defines screencasting, provides a short history of library tutorials, and explains

how screencasting helps libraries. Chapter 2 explores available solutions, such as free web-based software, free downloadable software, commercial options, and hardware. Chapter 3 shows you how to set up an environment conducive for the screencast, choose a topic, plan a click path, and choose your host. Chapter 4 covers how to gain support from administrators, collaborate with other library staff who are interested in screencasting, and confront accessibility issues. The step-by-step projects in Chapter 5 progress from short and simple to more full-fledged tutorials using special features. This chapter shows you how to make short instructional videos to demonstrate online tasks, such as effective uses of specific databases, your catalog, social media sites, discovery engines, and other resources. Chapter 6 tells you where to publicize and how to use RSS feeds and print marketing to capture users. The best practices discussed in Chapter 7 give you real-world advice about getting started with screencasts. Chapter 8 shows you how to find out whether or not your screencasts are reaching and helping their intended audiences. Chapter 9 forecasts some developing trends, and "Recommended Reading" at the end provides a great annotated list of blog posts, articles, screencasting opinion pieces, and software tutorial websites.

A screencast is a visual digital recording, often containing audio, that shows viewers information about a particular subject. *Screencasting for Libraries* offers tips and techniques for creating engaging library training screencasts along with a variety of software choices and different options for publishing screencasts on the web. From planning to software selection to microphone choices, this practical primer provides step-by-step instructions to make you the best screencasting librarian possible.

INTRODUCTION

- ► A Brief History of Library Tutorials
- ► How Screencasting Can Help in Libraries

Screencasting lets librarians demonstrate, teach, and guide our library users to all types of our online resources—from complex databases to simple online books. A screencast is a video recording with an audio narration of screen actions. Rather than just a video of a person sitting at a computer with a hard-to-read screen, a screencast focuses on what happens on the screen.

It teaches graphically, and reinforces with audio, the exact process and steps that a user needs to follow to get a specific result. A screencast video can show a user just where to click on the page, which limits to choose, and how to navigate through an online resource. Most importantly for busy librarians and trainers, screencasts can be very quick and easy to create so that it can take little more time than an in-person interaction to personalize a screencast for a particular question. In addition, more sophisticated software can be used to make more extensive, online training tutorials for those with available time and such a goal.

► A BRIEF HISTORY OF LIBRARY TUTORIALS

Librarians have been creating tutorials for decades, at least. Paper worksheet tutorials helped students learn to use library card catalogs and print indexes. With the rise of the web and the movement toward online library resources, tutorials moved online as well. For example, the Texas Information Literacy Tutorial (TILT) was well used in Texas and elsewhere because it was made freely available in a way that could be adapted to other local situations.

In working on an earlier book, *Teaching Web Search Skills*, I reviewed a wide variety of online library tutorials. For that book, I was particularly seeking tutorials that covered web searching topics. In general, I found two types of tutorials: the well-designed ones with good graphics and low-quality content and high-quality content tutorials that were text-heavy with little or poor

graphic content. The best obviously took a long time to develop and often involved multiple creators.

In addition, particularly with web searching, the pace of change in technology was quick enough that every tutorial had at least some outdated material. Given the long time and amount of effort typically used to create a library tutorial, and the increasingly rapid rate of change with so many online library systems, this style of production did not seem sustainable. As I continued to poll attendees at many of my workshops, I found that many librarians started to work on extensive online tutorials but that the efforts often failed to reach fruition.

This problem is exacerbated by the growing number of online resources to which libraries subscribe. A few years ago, librarians at the New York Public Library complained to me about how difficult it was to keep current with their 600+ databases. With so many databases, online journal packages, e-book collections, and other online library resources platforms launching new versions every year or two, that can translate to an average of one or two changes per day!

What I also found disappointing about many of the library tutorials from the early 2000s was that they were, in a word, tedious. As with TILT, many started by explaining how to navigate the tutorial. Then they followed the advice of that time to add interactivity. This was often accomplished by asking the viewer to click the "next" button to move on to the succeeding section. Interactive, yes, but it made going through the tutorials extremely tedious.

Then, one day, I came across an early screencast by Jon Udell, a well-known computer columnist for a succession of magazines and now continuing life as a tech blogger and evangelist at Microsoft. Jon created an eight-minute screencast demonstrating how *Wikipedia*'s history function tracks every version of a *Wikipedia* article. I had never used that function in *Wikipedia* previously. The screencast started with an explanation from Jon, and then in the video he progressed through various versions of the article using the history to move from one to another.

Heavy Metal Umlaut Screencast

Jon's original screencast is still available at http://jonudell.net/udell/gems/umlaut/umlaut.html. Jon was the one who, when wondering what to call this type of video, decided on the term "screencast" after he ran a "Name That Genre" contest for it (Udell, 2004a). Two people, Deeje Cooley and Joseph McDonald, suggested the winning name (Udell, 2004b).

Rather than forcing me to keep clicking on the next button, and presenting lengthy textual descriptions of the process, I could just sit back, view, and listen. It was much easier to understand the point, and the screencast had controls at the bottom so that I

could jump back to watch a section again, pause the screencast, or jump ahead. I could also control the volume. It was more like the television model, and to me, at least, it seemed that I learned the concepts much more quickly with less effort than a traditional click-through-me-one-step-at-a-time tutorial.

▶ HOW SCREENCASTING CAN HELP IN LIBRARIES

Libraries continue to buy online resources, make their contents available via the web, and aim to help users in both the physical library and the virtual library. Computers dominate in libraries. With the large number of resources available, and frequently changing user interfaces at each one, reference and instruction no longer occur only in person. Many new technologies can help, but screencasting can make it quick and easy to produce an instructional video of screen activity along with an explanatory narration. These can be quickly and (relatively) easily shared with an individual or a group or the entire online public.

Shortly after first viewing Udell's screencast, I downloaded the free 30-day trial of TechSmith's Camtasia Studio to evaluate the software. Then I received an e-mail reference question about how to find specific types of nursing articles. While writing out an e-mail answer outlining a roughly 12-step click path from the library website to CINAHL to the search results (and how to add the appropriate limits), I realized that this would be a good time to try creating a screencast for a reference transaction. A mere 45 minutes later, I was able to send the e-mail response along with a link to the screencast that demonstrated the 12 steps and appropriate limits.

Reference librarians at various libraries, while talking by phone or chatting online, have been able to create quick instructional screencasts to show patrons how to get to the requested result by the same process the librarians use by sharing exactly what steps they take to get there (Jacobsen, 2009, 2011). Electronic resource librarians use screencasts to troubleshoot access problems (Hartnett and Thompson, 2010).

Find some money in these difficult economic times to purchase a new e-book package? Instead of just announcing a new resource with a name that may well have no meaning to most users, create a quick screencast that demonstrates a few key features and titles from the resource.

Redesigning a website? Any time major website changes occur, long-time users can get disoriented. Use a screencast to show the differences between the old and the new site, highlighting where commonly used links have moved and/or been renamed. The screencast can include examples of how the new design makes common tasks easier, show off new features, and highlight where the most important parts of the site are now located.

Within live instruction sessions, a screencast can be used for several functions. It can show what off-site access procedures look like and how to navigate them, even if the instruction is taking place on-site. Use another for an introduction that teaches a process in a short and simple example. Screencasts can also be useful backups for instruction at a location where Internet access is spotty or unreliable. In a hands-on class, loop a screencast (without audio) that demonstrates a process while giving the students time to try it with their own examples, freeing you as the teacher to wander around the room checking on their progress while still providing an example of the process that they can view if needed.

Screencasts are also useful for promotion, outreach, and marketing. Host screencasts at YouTube (and/or other video sharing sites), and create a channel for the library to which viewers can subscribe and interact by posting comments, rating the screencasts, and even sharing responses. Create QR Codes or Microsoft Tags on printed promotional materials that link mobile users to screencasts about the library. The more libraries move online and the more experience you get with screencasting, the more ideas you will develop on how to use this exciting new technology.

▶2

TYPES OF SOLUTIONS AVAILABLE

- ▶ **Choose Your Software**
- ▶ **Choose Your Hardware**

▶CHOOSE YOUR SOFTWARE

When Jon Udell defined screencasting in 2004, there were relatively few screencasting software choices, and almost all of them were commercial and costly. Today, there are numerous free options, and the commercial options have continued to develop and offer ever more features. The choices are more complex, and the capabilities continue to increase.

Typically, commercial screencasting software is much more full-featured and more frequently updated and has more output and editing options. Even so, some of the free software can produce excellent quality screencasts. To make it easier to find the software that best matches your computing style, most of the commercial programs have free limited-time version demos you can download and try.

The choices described in this chapter are not comprehensive but are the best known and most useful for the library market. Many other software programs can make some kind of a screen-based video, but the programs discussed here have in common these three characteristics:

1. They record screen movements.
2. They can simultaneously record an audio track.
3. They can produce a Flash video (the most widely supported video format).

While the market leader for screencasting is generally considered to be TechSmith's Camtasia Studio, the number of other choices just keeps growing, and many of them can be used quite effectively to create quick and simple library screencasts. From free to fee and from simple to complex, there are now screencasting tools for every library budget level. Each program has its fans and foes. Try several to see which programs best match your style.

Free Web-Based Software

Several free options require just a web browser with Java to create a screen-cast. Because these are web based, they work on multiple operating systems and support a variety of browsers. Most of these have no editing capabilities and limited recording times. Still, they make it easy to get started very quickly. Simply go to one of these sites and within minutes you can create and publish a screencast.

In addition to a standard web browser, you must have the free Java plug-in, which are available on many browsers. Visit java.com and click the "Do I have Java?" link to see if Java is installed or should be updated. If it is not installed, it is free to download and install. For those at an organization with restrictive firewalls, you may need to contact someone in IT to have it installed.

Screencast-O-Matic

Screencast-O-Matic (http://screen-o-matic.com/) was the first-to-market of the free, online, Java-based screencast tools. Fortunately, it has continued to be developed. The free version is limited to hosting screencasts that are less than 15 minutes and places a Screencast-O-Matic logo on exported and YouTube videos, and a new Pro account ($12/year) allows up to one hour screencasts, removal of the logo, and editing tools.

The free version does include the ability to add notes at particular points along the timeline. These can be turned off by the user but are also displayed separately. Viewers can also toggle switches that highlight the cursor, emphasize clicks, or even remove the cursor.

Screencast-O-Matic differs from the other free screencasting hosting sites in that Java is also required to play the screencasts. Java is deployed widely but not quite as widely as some other web technologies like Flash. So, this requirement increases the chance that some potential audience members will not be able to view the screencast. However, the option to upload a screencast to YouTube makes it accessible to a much broader audience and offers greater marketing opportunities.

Screenr

Screenr (http://www.screenr.com/) is a simple, free, online, Java-based screencast creation and optional hosting site that is easy to use and designed for producing "Instant screencasts for Twitter." Although Screenr originally required a Twitter account to use, you can now log in with a Twitter, Google, Facebook, Yahoo!, LinkedIn, or Windows Live ID account, but you do need to have one of these. Screenr recordings are limited to five minutes. The videos can be hosted on Screenr.com and YouTube, or you can download the

.mp4 file. Screenr is now part of the Articulate Network (a full-featured commercial e-learning program that should help keep Screenr available for free).

Free Downloadable Software

The previous section highlights free online programs that have some basic features, but Java occasionally can be difficult on some systems. Running an online program and switching between it and the section to be recorded sometimes results in recording the recorder. So, other free alternatives that offer more features and a different recording experience are the free programs that must be installed on your own computer.

Jing

From TechSmith comes this free tool that can be used to create both screen-casts and screenshots. Available at http://www.techsmith.com/jing.html for both Windows and Mac operating systems, Jing was one of the first screen-casting programs for Macs. Jing comes bundled with limited free hosting at TechSmith's Screencast.com site (2 GB of storage and bandwidth).

The screencasting side of Jing does not include any editing capabilities, but it does make it easy to select just a portion of the screen. A Jing Pro account ($14.95/year) removes the Jing branding from the hosted webpages and also offers direct YouTube and Facebook uploading, smaller file sizes, MPEG-4 recording, and webcam insets.

In addition to screencasting, Jing can be used for taking screenshots. The screenshots can also be hosted at Screencast.com or saved to a local computer. The screenshot function does have some basic editing features like arrows and boxes.

Wink

Wink is another longtime free software program, available at http://www.debugmode.com/wink/ for Windows (with an older version that runs on Linux). It takes a different approach than many of the other programs in that it records screen actions as a series of screenshots rather than as video. The produced version still looks like video, but the series of screenshots approach allows for more editing capabilities. Wink can add callouts (such as speech bubbles, arrows, or squares that can contain text to highlight particular functions on the screen). It also allows the addition of images, next and previous buttons, shapes, and links to URLs.

Although Wink can record audio, even with the best of microphones the sound quality varies. Given the undependability of the audio, Wink may be

best used to create silent screencasts using callouts to highlight important points. This can work well for screencasts that are designed for use within public settings such as within a library. However, Wink does not include hosting, so the screencast files will need to be loaded on another site.

Webinaria

Visit Webinaria (http://www.webinaria.com/) to download the free screen recorder, available for Windows only. Webinaria records a series of screenshots, somewhat like Wink. After recording, limited editing capabilities include the ability to add text to the video for specified intervals. While these are not like other callouts in that they have no colored backgrounds, it is still a step up from choices without any editing capabilities. Webinaria can produce to the Flash .flv format or be hosted on the Webinaria site.

Commercial Choices

For anyone wanting to create more detailed and polished screencasts, the commercial choices provide far more features and stability than their free counterparts. A few years ago all the best programs were available only for Windows, but now most have Mac versions as well. The following sections highlight a few of the major screencasting programs.

More Extensive E-learning Options

Other commercial software choices that include more extensive e-learning packages are Articulate, Adobe Connect, and Lectora, which can produce screencasts but also have many other instructional functions, such as:

- ▶ Author Collaboration
- ▶ Version Tracking
- ▶ Project Management
- ▶ Student Tracking
- ▶ Synchronous Online Instruction

Camtasia Studio 7

For those who can afford it, Camtasia Studio (http://www.techsmith.com/camtasia.html) is one of the best and most feature-rich screencasting packages available. Made by TechSmith (which also created Jing, Screencast.com, and the Snagit screen capture program), Camtasia Studio retails for $299 (with discounts for bundle and bulk purchase and $249 for government or nonprofits and $179 for education). Camtasia for Mac is at version 2 and sells for less because it is newer. List price is $99.

The Camtasia recorder has several options available while recording, including highlighting the cursor and click, adding sounds for mouse clicks, adding captions and system stamps, and locking the recording area to a specific application. The editor's project view includes the ability to add images, multiple videos, extra audio tracks, and a picture within a picture that can show webcam input. Sections of the video can be cut. The audio

controls can raise and lower volume or replace a section with silence. Audio enhancements help smooth out volume spikes and remove background noise. Editing controls can be used to add title clips, transition between sections, create a wide variety of callouts, insert captions, zoom in to emphasize sections of the screen, and create a Flash quiz.

Camtasia Studio can publish to a wide variety of output formats, including Flash, .avi, .wmv, QuickTime, RealMedia (.rm), animated .gif, and .m4v. It can post directly to Screencast.com or an FTP server as well as create a file customized for YouTube uploading. A free 30-day trial has all features available with no watermark in the produced screencasts.

Adobe Captivate 5.5

Even more expensive, with a wide range of capabilities, Adobe's Captivate is another popular commercial choice. Beyond screencasting, Captivate (http://www.adobe.com/products/captivate.html) has options for interactive simulations, branching scenarios, and quizzes. Available in a variety of bundled Adobe products, it retails for $799 (or $299 for education customers). Long only available for Windows, the Mac version is now available at the same cost with the same features. With version 5.5, Adobe introduced an alternate subscription pricing plan of month-to-month ($59/month) or per year ($39/month). Captivate is also sold as part of the Adobe eLearning Suite 2.5 (which also includes Flash Professional, Dreamweaver, Photoshop, Acrobat Pro, Presenter, and Audition) for a retail price of $1,799 ($599 for an education version). The alternate subscription pricing plan is month-to-month ($135/month) or per year ($89/month). The new subscription pricing does not appear to be available for education purchasers.

With many of the same recording and editing features as Camtasia, Captivate differentiates itself with the more sophisticated branching options that let viewers interact with the video and choose where to go next. Creating such branching choices is more time-consuming and takes longer to learn. The Flash quiz features are more advanced as well. Adobe offers a free 30-day trial of Captivate, which includes all features and has no watermark.

ScreenFlow 3

One of the first full-featured Mac screencasting programs, ScreenFlow (http://www.telestream.net/screen-flow/) lists for only $99. Mac OS X Snow Leopard 10.6.4 or higher is required along with an Intel-based CPU (Core 2 Duo recommended). Many of the Mac programs primarily produce video in Apple's QuickTime format. For broader appeal, ScreenFlow can produce .wmv and Flash videos as well. A free trial is available that has watermarked output.

►CHOOSE YOUR HARDWARE

Screencasting requires very little additional hardware for most computers. Recording and editing video is processor intensive, so newer and more powerful computers tend to work better for long recordings and complex editing. Even so, older and less powerful computers should work fine for short, simple screencasts. Beyond the computer, the microphone is the one essential piece of hardware needed.

Microphones

The microphone will affect the quality of the audio recording. For most simple screencasts, the important part is that the audio is audible. It does not need to be perfect, and the speaker does not need to sound like a highly paid actor. In many situations, less-high-quality audio can give it more of an informal, conversational appeal.

Even a very inexpensive, basic computer microphone can work. Start by seeing what is easily available: internal microphones on laptops, clip-on microphones, standard desktop stand microphones, or headsets with microphones. You can spend anywhere from a few dollars to $100; in general, the sound quality improves as the cost escalates. Some microphones also can sound different on different computers. They can connect to the computer via USB or a direct microphone port (often colored pink). If several different types are available in your library, try a selection to see what works best for you. The microphone does need to be in a position that leaves hands free for typing on the keyboard, mousing, and general screen navigation.

Headsets

A headset with a microphone offers several advantages in many environments. Because part of the screencast creation process does involve listening to your recording, those in office areas with others nearby can avoid disturbing neighbors by using a headset. Beyond being neighborly, a headset keeps the microphone at a consistent distance from your mouth, which helps with the consistency of the audio input level. It can be easier to hear playback on a headset, and the general audio quality is better than with some of the less expensive microphones. Like plain microphones, headsets with microphones connect to the computer by USB or by two plugs for the microphone in and audio out ports.

Webcam

While most library screencasts do not need or use a webcam, many of the screencasting programs support using a webcam to create a video within the

larger screencast (called a "picture-in-picture" by some). Typically, the majority of the video area shows screen actions, but a small window will show a video of you talking as you narrate. Since this rarely adds much instructional value, most leave it out, but if there is a use for it, the more expensive webcams will have better quality video.

If a webcam is already available, most also have an internal microphone. So, even for screencasters who do not want to include a talking head, the webcam may function well as a microphone.

One caution to anyone experimenting with multiple microphones including webcam mics—be sure that the correct one is selected for input! I have had a headset and a webcam with microphone hooked up to a laptop with a built-in microphone. With three microphones from which to choose, the computer may not pick the one you intend. Check on the audio settings of the program to make sure that the one you intend to use is the one selected.

▶3

PLANNING

- ▶ Set Up the Physical Environment
- ▶ Create a Conducive Computing Environment
- ▶ Choose a Topic
- ▶ Plan a Click Path
- ▶ Choose Your Host

While most of the book is focused on the technical aspects of creating screencasts, from the software details to hardware tips and hosting choices, the real work for good instructional videos is done during the planning phase. For many of us, it is easy to get caught up in the ease of creating screencasts and using the software while failing to adequately consider the instructional aim, the examples to use that will support the aim, and the rehearsing to watch for distractions from the instructional goal.

Establishing an environment that is conducive to recording and minimizing interruptions and distractions is another aspect of planning. Both the physical space where the recording occurs and the virtual space on the screen of the computer doing the recording have environmental planning issues.

▶SET UP THE PHYSICAL ENVIRONMENT

Many of us are limited by our current office space as to how appropriate an environment it is for screencasting. Yet many small choices can help to avoid unexpected problems and streamline the recording process. Making space around the keyboard and mouse so that items are not accidentally knocked over is a starting point.

Some librarians have found it helpful when getting started to engage the assistance of a colleague, because it is initially artificial to talk to a computer on its own. By directing your speech to a person, the audio will sound more conversational and less stilted.

The phone and visitors are other potential interruptions. When you are perfecting the narration of a screencast and the telephone rings, loudly, in the middle of a word, you might think you need to start anew. Plan ahead and forward calls or turn off the ringers (both office desk phones and any nearby cell phones), and you can avoid this problem. Yet it is difficult to keep people from knocking on the door or walking in on a recording session. Closing the door and putting out a simple sign stating "recording in process, please do not disturb" will help.

If you share an office or your office is a more open (and potentially noisy) cubicle space, using a headset can help. The headset keeps your audio from disturbing others, and the attached microphone should primarily pick up only your voice. Also, plan to do the actual recording at what is usually a slow or quiet time.

However, there is no need to plan for the perfectly quiet environment. If your program has editing options, you can always rerecord over any unexpected noise, interruptions, or mistakes. Even with nonediting software, if the screencast is short, it can be just as quick to rerecord the entire screencast.

► CREATE A CONDUCIVE COMPUTING ENVIRONMENT

In a similar fashion, and perhaps even more importantly, create a conducive computing environment. First, minimize clutter. Focus the screenshots on the important parts of the topic to be taught rather than including distracting visual information such as other programs and alerts. Many new screencasters tend to record the whole screen with no changes to their usual computing environment. The web browser, including bookmarks, toolbars, add-ons, themes, and settings, along with the operating system toolbars, backgrounds, screensavers, taskbars, and extraneous icons all clutter the virtual desktop. When I watch a screencast that includes this type of clutter, rather than focusing on the instructional point, I try to decipher which browser is being used and why, what preferences the author has in terms of operating systems and theme preferences, and so forth.

So, to decrease bandwidth, scale the screencast size appropriately, and improve instructional delivery, avoid recording the whole screen (unless the instruction really needs it). Keep the recording areas small, and close down unnecessary programs. This will also help the screencast recording function better by freeing more memory for it. For web topics, instead of recording the whole web browser, just select an area within the browser window. Avoid including browser toolbars and any identifying personal choices. Close down e-mail, chat, IM, and other programs that might suddenly send up an alert in the middle of recording.

Adjust volume level and prepare an appropriate speaker/headset audio level before recording to avoid producing a product with audio so loud that it sounds like a badly designed television commercial or so low that it cannot be heard. You can adjust the audio after recording, but it shortens the process if you can set the environment to record an easily audible volume from the beginning.

I recommend that you first visit a professional news (TV or radio) website that has audio, such as NPR, CNN, BBC, or Fox News. Choose one with normal talking levels rather than a sensationalist site with unusually loud announcers. Play a news clip that has audio. Then adjust the volume on your speakers or headset to a comfortable listening level. After that, be sure not to change the speaker level. Record a short test with your microphone, speaking at a normal voice level, and then play it back and listen for the volume. If it is too soft, try to move the microphone closer or raise the recording volume in the screencasting program. Too loud, try the reverse. I found that my mistake was to just adjust the volume on my speakers after recording instead of being careful to create a comfortable volume level for other listeners.

For instructional subjects that show a process involving the browser or operating system, further planning is needed. Many of us have far too many icons on our desktops, and we do not want to lose those just to record a screencast. Just create a new folder, put all the icons into that folder, and then move the folder to some other area in your file structure (under My Documents, for example, for Windows users). Instead of your personalized desktop background, change it to a solid color or plain wallpaper.

Take a look at the old CustomizeGoogle screencast at http://www.customize google.com/movies/intro-flash.html as an example of this. The opening screen has just one single icon and a solid background color (see Figure 3.1). Firefox is the one icon because that is the only program being demonstrated. With no other distractions, the viewers' eyes are drawn just to the important part, and it has the added benefit of highlighting the video controls at the bottom, communicating to viewers that they can pause, rewind, and control their own viewing experience.

▶ CHOOSE A TOPIC

The key to good instructional screencasts is to choose a topic that is conducive to being demonstrated with a screencast and then using examples that clearly elucidate the main instructional points. This is easiest when responding to a specific request. For example, the user who asked, "How can I find peer-reviewed nursing articles on neuralgia that are evidence-based and focus on patients over 65 years old?" has given you a topic.

►Figure 3.1: CustomizeGoogle Opening Screen

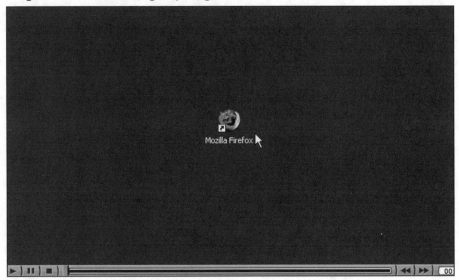

In most situations, however, you will need to choose the scope, topic, and examples. Look at what search statistics are available for your organization, and then consider topics that represent the most frequently encountered problems. Check reference query logs, catalog search logs, chat transcripts, database search logs, error logs, and website search logs, and talk to the frontline workers and teachers who handle the most questions. You will likely find a substantial number of ideas.

Once the topic is chosen, finding good examples can sometimes be the more time-consuming process. A frequent librarian failing (and one that I constantly battle myself) is that we want to include far more details than the student wants to learn. We add extensive textual descriptions or long explanations and also like to include all the exceptions and extra options. This breadth of knowledge is often our strength, but we can lose viewers by sharing too much. Tutorials like TILT, mentioned in Chapter 1, which includes extensive instructions on how to navigate the tutorial, are typical examples of this. So, when choosing the scope of a screencast, start by thinking of just a few key points rather than expounding on peripheral themes.

For example, when creating a library catalog screencast, you could include dozens of examples and searches. Instead, limit the scope to the most frequent types of searches. Even just one basic search each for author, title, and subject can get lengthy. Consider creating three separate screencasts that are linked instead of one that includes everything.

Look for static examples that are unlikely to change. If you pick something that soon becomes a hot topic, the screencast ends up showing how things used to be rather than what the new results look like. The goal is demonstrating an example that the students can replicate themselves.

Sometimes, finding an effective example may require many attempts. For example, searching in the catalog for an example for a subject search, I wanted something that might be of some amusement to college freshmen, that would have only a single record (so that either a keyword or a browse subject search would work), and a term that might not be immediately known or obvious to the audience. I ended up using "night soil," which yielded only one book in our catalog, was not a term familiar to me, and turned out to refer to human excrement used as fertilizer. While I am still not sure that it was the best subject term to use, it was the closest one I found that met all or most of the criteria—and that was after trying dozens of other subject headings.

One great way to build a supply of good examples is to keep an eye out for them in other instruction and reference works. Then bookmark the search or otherwise record the searches that work well so that you can use them at a later date when trying to create an instructional screencast.

What do you do if you cannot find an example that meets all the criteria? Perhaps it is time to rethink the instructional aim. If many of the examples you find work differently than you want the ideal one to work, maybe you should be creating a screencast that shows how to work around the problems that occur.

▶ PLAN A CLICK PATH

Once the topic and examples are chosen, determine the search steps from the starting point to the results. This is the click path, the virtual road that the user takes to get from one webpage to another and that is the outline for the entire recording. The click path includes the starting page, the links to follow, the examples used, and any notes about the key points you want to make. A click path can include just the names of links, but many times it is broader and includes search terms to use, options to check, dropdown menu choices, or spots to mouse over.

For some very simple screencasts, especially those that will be used only for a short time or to communicate with a single individual, the click path can be developed on the fly. For an instructional screencast that will be used by more people and that may be updated as interfaces change, it is extremely helpful to save the click path in a document or printed and filed. A print copy can be put on the desk and checked as you record the screencast. Those who

use multiple (or sufficiently large) monitors can have the electronic document open for reference. Planning ahead which links to click, which examples to use, and which sections of the screen to highlight prevents you from recording an entire screencast only to realize later that you left out a key point. For processes with extensive click paths, writing it out allows you to consider the instructional impact of the sequence and to rearrange it so as to get the most important points near the beginning.

Having a copy of the planning document and the click path will help tremendously when a year has gone by and you need to rerecord the screencast because the vendor has launched a new interface. Just pull out (or pull up) the click path, run the same examples through the new interface, and update the names of the links or the options. Then, with a quick rerecording, you will have an updated tutorial with a minimum of effort.

The following click path demonstrates how to search a Gale InfoTrac database for the local-interest topic of "skiing":

1. Start at library homepage.
2. Click on "Articles (Indexes and Databases)."
3. Click the "InfoTrac Powersearch" link in the Best Bets section near the top.
4. Search for "skiing."
5. Click "subdivisions" and scroll to History.
6. Click "History."
7. Show record #2 for HTML full text.
8. Show record #3 for PDF.
9. Show record #4 for no full text in database.
10. Click "Check MSU Availability."
11. Click "Article" to show access to full text in another database.

Chapter 5 has more examples of click paths, including steps to outline notes for points to make in the audio narration and target times.

Writing a Script

Some librarians prefer to write out an entire script. A script certainly has many advantages. It can be used to easily add closed captioning for the hearing impaired, to incorporate changes during future updating, and to lessen anxiety during production by knowing what to say. On the other hand, some people sound stilted when reading a script rather than sounding conversational. In addition, writing a script can take much more time, and one significant advantage of screencasting as a technology is that, with a bit of practice, it should allow for the very rapid production of instructional videos.

Storyboarding

Another planning technique common in video production is creating a storyboard. It typically consists of an image with accompanying notes that outline the sequence of events. Storyboarding can be done by hand (many free templates are available online) or on the computer. For screencasting, the online version can be as simple as a screenshot of the action on the left and notes about what to say on the right. Even quicker is a purely textual approach with a description of the action on the left and the script or outline on the right, as shown at http://libcasts.library.dal.ca/International/English/Englishscript.pdf (see also Figure 3.2).

Templates for sketching out a click path or creating a simple storyboard are available on the companion website (http://www.alatechsource.org/techset/).

Rehearsing

As with the click paths, it may not be necessary to rehearse for some simple screencasts and for ones used to reply to an individual. For more extensive ones, even a quick rehearsal of the click path can save time in the long run. On the computer's side of the process, running through the click path can uncover problems, such as pop-up windows that move out of the recording zone, examples that fail to work right (even though they may have worked previously), and sections of the process that need further planning. Some databases use pop-up windows for certain functions and content. By rehearsing the process, you can ensure that pop-up windows are positioned within the recording window before the recording starts. Leave that window in the

▶ Figure 3.2: Text-Only Storyboard

Libcast Basic Storyboard	Title: Welcome International Students Content: welcome, academic, libraries, website, help, resources
Screen shot	**Script**
Title	Welcome to Dalhousie and the University Library System. This libcast will give you a quick overview of our resources and services. We have many other libcasts in English that cover these resources in detail. We hope that you will take advantage of all that we have to offer.
Image of A&A > Killam?	Coming to university and pursuing a degree means that you become part of the academic culture. As such, you are expected to do research and use scholarly resources such as journals and databases. Just using the internet and Google is not enough to be successful.
Image of student studying > pic of 4 libraries	You are not expected to already know how to do academic research but you are expected to make sure that you learn. We have four libraries on campus that provide a variety of ways for you to acquire the skills you will need.
Students & books	Academic research includes using books, scholarly journals and databases. All of

background, and you can then just switch to it (Alt-Tab in Windows) at the appropriate time to mimic the actual behavior.

On the human side, rehearsing helps reinforce what you would like to say and how long you might spend on each part of the click path. If you tend to forget what to say, find a transitioning remark and add a note about that to the click path. If you find yourself making a very lengthy explanation during the rehearsal or wandering off into extraneous topics, consider either adding the new topics to the click path notes or finding a shorter, simpler explanation to use.

▶ CHOOSE YOUR HOST

Choosing an appropriate hosting option is an important part of the planning process. Hosting choices have proliferated, but some may be limited by the situation within your organization. Libraries with no local web server cannot host on what does not exist. Internal screencasts within organizations concerned about privacy will not want to use public hosting sites, depending on the level of privacy needed.

The growth in hosting options makes the decision process complex. Some basics to consider include:

- ▶ Privacy: What level of access do you want to provide?
 - ➤ Open to all on the web and findable by anyone?
 - ➤ Open web-wide but only to those with a link?
 - ➤ Available only within your organization?
 - ➤ Available only to specified individuals?
- ▶ Social content
 - ➤ Do you want viewers to be able to easily comment, rate, and reply to the video?
- ▶ Embedding
 - ➤ Do you want it to be easy to embed the screencast in blogs, guides, and other webpages?
- ▶ Statistics
 - ➤ Do you want the hosting service to provide viewing statistics?
 - ➤ Do you have another statistics package and want to integrate the screencast statistics into the rest of the usage statistics?
- ▶ Branding: Surrounding content control
 - ➤ Do you want to include local branding and add surround text, links, or navigation?
- ▶ Flash functionality
 - ➤ Are you producing a screencast using Flash features such as hot spots, quizzes, or table of contents?

▶Table 3.1: Cloud versus Local Hosting Options

	If Not Important, Use...	If Important, Use...
Privacy	Cloud	Local
Sharing	Local	Cloud
Embedding	Local	Cloud
Statistics	Cloud has basic counts	Local can be integrated into full site analytics
Branding	Cloud, but some branding possible	Local
Flash functions	Cloud	Local or Screencast.com

Consider your library situation and then use Table 3.1 to help you decide which hosting option to choose: cloud hosting or local hosting. These guidelines are very general, as there are exceptions and more detailed issues with each approach that depend on the specifics of the cloud or local server.

Cloud Hosting

As more and more applications and devices rely on the Internet for connections and activities, the cloud hosting options will continue to multiply. "Cloud computing" is a somewhat nebulous phrase referring to programs, tools, and services that are virtual, that is, basically run on the Internet. Think of an online word processor like Google Docs or Zoho Writer as a typical cloud application as opposed to software like Microsoft Word or Corel WordPerfect that are programs installed onto a computer.

For screencast hosting, a cloud option is a hosting service that is located somewhere outside of your organization on the web that makes your content available to others. While YouTube is the best known and the market leader, there are many others that handle video in general, such as Viddler, Vimeo, and Blip.tv, and screencast-specific hosting at Screenr, Screencast-O-Matic, and Screencast.com.

Most cloud hosting options are designed for full public sharing of videos. However, many now also have a private option that limits access to no one other than the creator or to a specific group of users. If the private option requires that the viewers also have an account on the system, this can limit access by your potential viewers if they choose not to register. More helpful are options like YouTube's "Unlisted," which means that anyone who has the link can view the video but that it will not get added to search engine results.

Most social video sharing sites come with basic statistics of the number of video views and let viewers leave comments, rate the video, and share it with others. Sharing can be via Facebook, Twitter, e-mail, and a variety of other

social networking sites. Most also give embed code that can be (sometimes customized and then) copied and inserted into a blog or other webpage. For those without the permission to store videos on the library web server or without a library web server, this allows the screencasts to be made available and then either embedded or linked to.

On the negative side, cloud hosting may come with advertising, links to other purportedly related videos, and reduced video quality. Videos are typically uploaded in straight video formats (such as QuickTime, .avi, or .wmv) and will not support Flash features like hot spots, quizzes, table of contents, and continue buttons. Many also limit the video duration (no more than 15 minutes at YouTube, 5 at Screenr, and 15 at Screencast-O-Matic).

Free Choices

While Viddler, Vimeo, Screenr, and Blip.tv, and many other sites have similar features, YouTube is the best known and most used video sharing site. With some of its newer features, it can be used quite effectively for sharing screencasts and even for a bit of editing (as discussed further in Chapter 5). Common complaints about YouTube hosting are the ads (which help make it free but distract from the learning experience), the suggested videos on the side, and the related videos YouTube suggests at the end of the video. One way to avoid ads and related videos is to use the YouTube embed code and post the screencast on your own site, blog, or intranet.

Another way to share is to link to the video itself rather than to the YouTube interface:

1. Click the "Share" button below the video.
2. Click "Options" under the box with the URL.
3. Check "Long Link."
4. Copy the URL in the box and then replace the /watch?v= with /watch_popup?v= within that URL.

This enables the video to fill the browser window so that it does not display surrounding content like ads, suggested videos, or (on the down side) the statistics, ratings, and comment form.

The related videos can be turned off when embedding a YouTube video. When generating the embed code, note the options below the code box and unselect the "Show suggested videos when the video finishes" box.

Screencast.com is another free choice designed to share screencasts and images, but it offers only limited capacity. The free version allows storage of up to 2 GB of content and a monthly bandwidth cap of 2 GB. This can be more than sufficient for many screencasting projects as long as you do not expect heavy traffic or plan to host numerous long screencasts. Unlike

all the other video hosting options that I have tried, Screencast.com does support some Flash functionality (which is not surprising because it is run by TechSmith, the maker of Camtasia Studio, which has several Flash functions). Just monitor the monthly bandwidth use and delete older content to keep within the limits.

Fee Choices

Screencast.com Pro is one commercial option. Instead of the 2 GB content and monthly bandwidth cap, the Pro version allows up to 25 GB content storage and up to 200 GB of monthly bandwidth. It costs $9.95/month or $99.95/year. Screencast.com Pro also supports branding with background templates, which can include a logo and your choice of color scheme, and you can customize what appears on the view page.

Vimeo is preferred by some for its higher video quality and absence of suggested videos at the end of play. Vimeo's commercial version, Vimeo Plus (see http://vimeo.com/plus for current details), increases storage space from 500 MB to 5 GB/week. Features include player customization full control, advanced statistics, domain level privacy, high definition embedding, and more.

Local System

Libraries with a website hosted on a local server can have much more flexibility for certain screencasting functions, depending on how tightly controlled the server is and any local policies that may prohibit certain uses. On the other hand, it may take more development to add in the social interaction capabilities that come with cloud hosting. Local hosting has the benefit of allowing consistent branding, integration with the rest of the library site, full video quality, local control, and no advertising, no bandwidth limits, and no links to unrelated videos. It can support the full range of Flash features like hot spots, quizzes, table of contents, and continue buttons.

Locally hosted screencasts can be linked from the website and shared with the entire Internet audience, or they can be placed behind a firewall or on an intranet that limits access to just viewers within the organization. For even greater levels of security and privacy (if such is needed), a screencast can be posted in a private directory that is password protected or limited to only certain IP addresses. While screencasts are best when short, if you do decide to produce a lengthy screencast (like a lecture capture, for example), local hosting gets around the time limits at many cloud hosting sites.

Depending on the screencasting software being used, it may take more work to make the screencast available. The commercial programs can create

a set of files in a subdirectory that include an HTML page with the proper code embedded. Just copy, transfer, or FTP that directory to the web server and then link to the HTML file. Screencast-O-Matic can produce an .mp4, .avi, or .flv format file for download, and Screenr can produce an .mp4, but to get those files displayed on a website takes creating some complex object embed code, preferably with another file for the controller. This is a complex enough process that the easiest way is to combine cloud and local server. Just upload the .mp4 to YouTube or another cloud site and then use the embed code from that site. This does mean that Flash actions will not be supported and that the actual video file is hosted in the cloud, but you can still get the other benefits of local hosting.

►4

SOCIAL MECHANICS

- ► Gain Support from Administration and Systems
- ► Expand the Pool of Creators
- ► Get Library Staff on Board
- ► Evaluate Accessibility Choices

You have found software that you like, tried a few examples, and are ready to produce a few instructional screencasts for your users. Now, how can you sell others in your library on the idea? You may want funding from administrators for purchasing software. The webmaster must approve links from the library website and be consulted about possibly hosting screencasts on the site. The library newsletter editor could write a feature on the new initiative. Colleagues could integrate the screencasts into instruction sessions or workshops. Reference librarians could use screencasting at the desk.

As with any new technology, the first adopters may have an uphill battle to convince others in the organization to be as enthusiastic about it as they are. Depending on the library, there might be enthusiasm at first, but, after a year or two, some other technology excites everyone and the challenge is to continue the activity.

The good news these days is that there are compelling free software options and free cloud hosting choices. This makes it easy to create some no-cost demonstration screencasts before approaching others in the organization. While exploring the software and hosting choices, create some demonstrations that both help you evaluate the software and give you something to show others to help sell the concept.

►GAIN SUPPORT FROM ADMINISTRATION AND SYSTEMS

Depending on your library situation, two groups to consider approaching early in the process are the administration and computer support. Administrators like to see clear goals and costs. Find a few examples of where the use of

instructional screencasts will clearly benefit library users. For costs, consider not only the potential monetary expenses but also the cost in time for creation. At any library that is planning to contract out for tutorials or videos, the ability to quickly create screencasts for little or no cost is likely to appeal to an administrator. Having administrative support can also help when selling the idea to others.

Systems can be a more difficult situation, especially in libraries that have very tight security policies (some librarians have no access to the outside web, and some libraries prohibit Flash). In these more extreme cases, two options for screencasting could help. If the intended audience consists of internal users working within the firewall, purchasing commercial screencasting software and hosting content strictly on the intranet behind the firewall could work. On the other hand, if Flash is not allowed, this pretty much kills the idea of using screencasts.

In more typical situations, systems may have concerns about bandwidth, may be reticent to allow direct server access for hosting, or may just not like change. In these cases, clarify that the hosting will be off-site (e.g., YouTube, Screencast.com, or Vimeo) and thus would not need direct server access, would have no bandwidth impact, and would not cause much change. With more amenable computer techs, point out how they could benefit from the technology. Show them a screencast about a specific problem (like Project 2 in Chapter 5) or about how a new systems change is supposed to work.

► EXPAND THE POOL OF CREATORS

In a small library, it may be completely appropriate to have just one person producing screencasts. In larger libraries, it can help increase the quantity and quality of screencasts to have several people empowered to create them with the added advantage of being able to work collaboratively and inspiring each other. To expand the pool of interested parties, keep the barrier to entry as low as possible. Try to get the software installed on the computers of those most likely to be interested. If using web-based software, make sure that each person's computer has Java that is up-to-date. Then schedule some training sessions or times to get together and at least play with the software.

One of the difficulties in hands-on training sessions is to find a computer lab or classroom with sufficient microphones to be able to practice speaking. Headsets work best, because a room full of people all speaking and recording at once can be challenging for them to concentrate on their own narration rather than their neighbors'. However, if the group is not too large and everyone has a headset, it won't be as noisy as you might expect unless some have very loud speaking voices.

Smaller training sessions with just a few people or one-on-one sessions can work well, although this is more time-consuming. If an environment is available with a number of small rooms, offices, or other enclosed spaces, a roving instructional session can work, where each student goes into the separate space to practice recording and the instructor roves. Alternatively, demonstrate the technology in a large group session initially. Make sure each staff member then has a handout and access to the appropriate hardware and software, and then give an assignment to be completed on their time in their own space. Follow up with a session to display the results and continue with more advanced topics.

Agenda for Screencasting Staff Training

Start with easy-to-use software and a simple hosting site.
- ▶ Show a quick screencast demo.
- ▶ Demonstrate the software (Screenr or Screencast-O-Matic):
 - ➤ Share institutional account information.
 - ➤ Demonstrate a quick topic from recording to generating the URL to share.
- ▶ Provide a potential use overview:
 - ➤ Give examples specific to your library.
 - ➤ Lead discussion to get audience to generate more ideas.
- ▶ Give a second demonstration:
 - ➤ Create another screencast from the discussion ideas.
 - ➤ Option: Start recording, stop, and then show how to delete and start over.
- ▶ Solicit questions.

For remote hosting, consider creating an institutional account at YouTube, Screencast.com, or another site. It does not need to be an official institutional account (if such an option is available). Just use a name like "My Library" and an e-mail account that can be shared (e.g., set up a separate Gmail, Hotmail, or Yahoo! Mail account). Then share the username and password with others, or make it easily available and linked on a secure intranet.

▶ GET LIBRARY STAFF ON BOARD

Market your success internally. Let others know when you get positive responses to a particular recording. Announce when new screencasts have been published, and ask for internal feedback. Identify other key early adopters and help them to market their screencasts as well. The internal marketing of the new ones you create may also inspire others to talk to you about collaboration and ask how they can also create screencasts.

Use an internal blog, discussion forum, or other social networking application for staff to share information and links when you create a new screencast. Add details about the process and thoughts about the instructional impact. Share any feedback you get with other staff as well. Instead of pressuring others to try screencasting, aim to share success stories and lead by example.

▶ EVALUATE ACCESSIBILITY CHOICES

Many libraries and organizations aim to make all of their instructional content and websites as accessible as possible. Know your organization's guidelines and practices before approaching administration, systems, and colleagues, and be prepared to answer questions about the accessibility of your screencasts. With a bit of preplanning, many accessibility issues can be addressed.

Because screencasts rely on the visual and audio delivery of information, these are key areas of accessibility concern. For the visually impaired, the audio track of a screencast can provide the necessary information as long as you remember to include appropriate instructions. For the hearing impaired, several screencasting programs support the addition of closed captioning. Camtasia Studio, Adobe Captivate, and even YouTube support closed captions by simply synchronizing a script with the screencast. Sometimes called "subtitles," the closed captions work best when they are written by those who need them (closed) as opposed to just visually repeating the words in the audio track (open). According to Sweller (2005: 164), research demonstrates that "having identical written and spoken text was redundant and interfered with learning." Clark, Nguyen, and Sweller (2006: 128) also advise, "don't describe visuals with words presented in both text and audio narration." So, instead of using open captioning and potentially detracting from the learning experience, use closed captioning.

Not all screencasts need to be captioned. A screencast created for support personnel or for an individual reference response, where the intended audience is known to have visual and hearing acuity, should not need captions. This is also true for an organization or school with no students who need accommodations.

So, know your environment and coworkers. In any environment where there is already an accessibility policy or other efforts at accessibility, be prepared. Create a short screencast with closed captioning. Create alternative versions for the same video—one with audio and one with open captions—and sell it as useful both for accessibility for the hearing impaired and for use within public computer labs (where no speakers or headphones are available). Instead of letting accessibility become a stumbling block, let the variety of accessibility options in screencasts become a selling point for the technology.

►5

IMPLEMENTATION

- ► Make a Quick Screencast for Students
- ► Make a Quick Tech Support Screencast
- ► Create an Individual Tutorial with Audio
- ► Create a Quick Demo for E-mail Reference and Library Promotion
- ► Add Callouts to a Screencast
- ► Produce a Basic Database Tutorial
- ► Create a Screencast for a Blog Post
- ► Make a Class Assignment Tutorial
- ► Edit Screencasts (Camtasia Timeline, Audio, and Callouts)
- ► Create Screencasts with More Special Features Using Camtasia Studio
- ► Create an Instructional Aid Screencast (No Sound and Dual Purpose with Sound)
- ► Add a Quiz and Captivate Overview

As people get used to creating screencasts, more ideas and possibilities emerge for using screencasts for instruction. Many project ideas can be implemented completely with free software, and the screencasts can be quick to create. The series of projects included in this chapter start with the simple, free software created, and freely hosted variety. As the chapter progresses, the projects get more complex and introduce editing options, local hosting, embedding, and combined screencasts.

The screencasting result of each of these projects is available online, linked from the companion website (http://www.alatechsource.org/techset/). In addition, for some, an accompanying screencast will show the process of

creation (as well as how a screencast of a screencast creation process can work). So, as you read through these projects, take a look at the accompanying screencasts themselves to see the results of the tasks outlined here.

If you set up accounts and download trial versions of software, you can also walk through each of these projects yourself as you read to get hands-on experience with screencasting and all the features described here. I use a number of recording programs and hosting options. This variety is important when trying to get to know software and hosting options and for choosing what combination might work best in your environment. However, for most of us it works best if we can find one software and hosting combination that works best for us (and is affordable) and then stick with it. If you follow along with each project, you will gain a broad range of experience to help inform your eventual decision.

► MAKE A QUICK SCREENCAST FOR STUDENTS

A great way to get started with screencasting is to dive in and start using some of the software. With so many free recording and hosting options, all that is needed to get started is a computer with Internet access. To help make initial screencasts less daunting, start by creating one for a small, targeted group. In this first example, here is a screencast project to respond to a group of students needing help with a database.

Project 1	
Audience:	A group of students working on a project
Software:	Screenr
Hosting:	Screenr
Topic:	Database Searching: CINAHL

For this example, I will use an updated topic based on the e-mail reference question that first got me creating screencasts. After getting the question from one student and hearing that a large class had the same assignment, I created a screencast showing the steps for getting into CINAHL and searching for peer-reviewed, evidence-based articles on dementia care.

Establish a Screenr Account

Screenr takes a bit different approach to account sign-ups than do most sites. Instead of establishing a separate Screenr account, just log in with an existing account you already have at Twitter, Facebook, Google, Yahoo!, LinkedIn, or Windows Live ID. As long as you have an account on one of these systems, you can log in to Screenr and use it to create screencasts. Because Screenr is free, it works well as a program for initial screencast creation and experimentation.

Sketch Out the Click Path

A brief amount of preplanning will help the screencast go more smoothly. To prepare for recording this screencast, first go through the steps several times, and outline a click path to use for the recording. The following list shows the sequence of steps to take and reminds me of what is next, in case I forget. The click path outline also can be used to check for changes in the future.

1. Go to the library homepage.
2. Go to Databases.
3. Go to Nursing and Medicine.
4. Go to CINAHL.
5. Check boxes for "Peer Reviewed" and "Evidence-Based Practice."
6. Enter "dementia care" into the first search box.
7. Click "Search."
8. Expand results count box to show limits.

In addition to rehearsing these steps, check to see how small of a browser window will work that can still display the key instructional points. I start with our library catalog in a browser window. I make the recording area smaller by resizing that window. While this is by no means required, it is good to get into the habit of using smaller windows for recording so that viewers can see the important parts of the video more easily. Too many beginners record the full screen, which can result in making it difficult to see which link gets clicked. For this project, dimensions of about 750 × 525 pixels work well.

Record in Screenr

Ready to record? Open up a new browser window for Screenr in addition to the browser window with the library catalog (the starting screen). Pressing "Control-N" is a quick way to do this in most browsers. Be sure that any external microphone is plugged in to the computer before starting Screenr. Log in, and then click the "Start Recording" button. It may take a few minutes for the Java recorder to load. Once it is loaded, resize the recording square to cover the content window.

Checking the microphone level is as easy as speaking in a normal voice and making sure that the colored lights on the audio scale move and that the scale is not constantly in the red. Then click the red button to start recording (see Figure 5.1). Screenr starts after a countdown of three seconds to give you time to be ready to begin. Record the screencast using the click path as a guide, and explain each step along the way. Remember that Screenr limits recording to five minutes or less and that shorter is better. So aim to be concise using clear, short descriptions as if showing a student at the reference desk

► Figure 5.1: Screenr Recording Screen

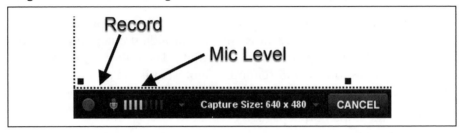

when you know the student has only a minute or two before class starts. End recording by pressing the "Done" button.

Publish in Screenr

If you are satisfied with the recording, you are ready to publish. If not, delete and rerecord, but remember that the goal, especially for an early project, is not perfection but speed of creation. When you are ready, continue, and Screenr will prompt you for a description of the screencast. Note that it cannot be longer than 117 characters. This length is based on the Twitter 140-character cap, leaving enough characters for the shortened URL that will link to the screencast and a default prefix. The description is required, so fill it in and then click "Publish." The publication process can take several minutes, but, once it is finished, your screencast is done, and you are ready to share it with the students.

Publishing the screencast makes it available on Screenr's website to anyone who can find it. It is also automatically included in Screenr's "Public Stream" of newly created videos. Once it has been published, note the sharing options available on the right-hand side of the screencast (see Figure 5.2).

► Figure 5.2: Screenr Sharing Screen

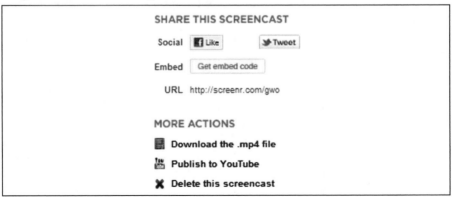

There is a direct URL that points to the Screenr-hosted version, along with embed code for displaying it directly on another webpage. Just share the direct URL with the class teacher and students you know, post it to a LibGuide, or add it to a course page in a learning management system, and the students can view and learn from your first screencast.

▶ MAKE A QUICK TECH SUPPORT SCREENCAST

Finding audio intimidating? Another way to get started and make initial screencasts less daunting is to create a screencast for an audience of one. In this example, we use a screencast program to capture an error in a library resource. It will be shared with just technical support, who can then see exactly what you are seeing and better understand the problem.

For this example, I will use an error in the design of pages within our library catalog that sometimes caused the header to disappear. To share the problem with our catalog support person, I just record the screencast with video only, no audio, so as to quickly highlight when and where the problem occurs.

Project 2	
Audience:	An individual catalog tech support
Software:	Screencast-O-Matic
Hosting:	Screencast-O-Matic
Topic:	Catalog Design Error

Establish a Screencast-O-Matic Account

One of the great advantages of Screencast-O-Matic, one of the first free online screen recording and hosting sites, is that it has several hosting options. All that you need is a modern web browser with a recent version of Java.

To get started, go to http://www.screencast-o-matic.com/ and find the "Login" link in the upper-right corner of the screen. Although an account is not required to record and share, it is free and makes it easier to keep track of screencasts that you have created. The current version of the site does not have a separate registration link, so just click "Login" to get to the registration form. Beyond agreeing to the terms of service, users just enter an e-mail address and password to register.

Record the Screencast

After successfully registering, you can start recording right away by clicking the large "Start Recording" button in the upper-right corner. After resizing the window to about 750 × 550 pixels, I quickly run through two examples that display the error, and create this click path to use when recording:

1. Start in the library catalog.
2. Click "DVD Search."
3. Search for "xtwain."
4. Show missing header error.
5. Click "OK" to show second example.
6. Search for "twain."
7. Choose first record.
8. Click "Details."
9. Click "Catalog Record."
10. Click "InDigEnt."
11. Show missing header error again.

Taking a few minutes to run through the various screens provides an opportunity to make sure that the window is not too small to cause unusual display problems or that it accidentally masks the error that is the purpose of the screencast.

Next, go back to the browser window with Screencast-O-Matic and click the "Start Recording" button in the upper-right corner. This brings up the recording frame, which can be resized by dragging the corners. Switch back to the catalog window, and adjust the frame to cover the content in the window. For this example, there is no need to include the browser tool bars, scroll bars, or other surrounding content.

This example is not recording audio, so clicking on the audio icon in the toolbar and selecting "No Audio Recording" (as shown in Figure 5.3) turns off the microphone. Then click the red circle on the left of the toolbar to start the recording. Go through each of the steps, and then click "Done" on the toolbar to finish.

Host at Screencast-O-Matic

Now, return to the Screencast-O-Matic window. You should see a preview of the screencast along with several "What do you want to do with this recording?"

▶ Figure 5.3: How to Turn Off Audio

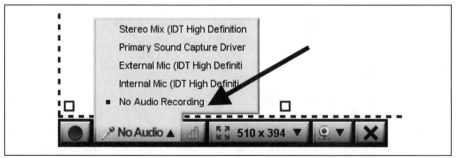

choices on the right. Click "Upload to SOM" to have the screencast hosted at Screencast-O-Matic (SOM). You are then prompted to add a title, description, language, and even notes at particular points on the timeline. Several other SOM options can be selected, such as making the screencast searchable and allowing users (or not) to add notes or comments.

Once you are ready, just click "Upload." Screencast-O-Matic will take a little bit of time to upload and prepare the video. Once it is complete, Screencast-O-Matic gives the URL for sharing along with quick links to share it via Facebook and Twitter.

Recording, publishing, and hosting the screencast at Screencast-O-Matic simplifies the process by keeping it all at one site. The only problem with hosting at Screencast-O-Matic is that potential viewers also need to have Java available to view the video. While Java has strong market penetration, it is not as commonly installed as you might think. A number of studies show that only about 75 percent of users have it installed. Because this recording is designed to be viewed by technical support, it should be safe to assume that technologically inclined workers would have it installed. Unfortunately, sometimes they are the ones who do not, for various reasons, so if in doubt, check with them first. If they do not have it installed or it is not easy to check with them, the YouTube upload option is available, and the next implementation example will cover how to achieve that.

Share Your Screencast

If you do not copy the URL at the time of initial publication, Screencast-O-Matic no longer displays the URL on the list of screencasts under "My Screencasts," nor is it on the edit screen. Click on the screencast graphic itself to get the viewable version, and then look for the "Share Link" section on the left for the URL to share with others.

For the initial intent of sharing this screencast with just one catalog support technician, simply copy the URL and insert it into an e-mail message. Remember that Screencast-O-Matic requires the viewer to have Java 1.5 or above installed (which is typically about 75 percent of the web public). Be sure to use the viewing URL, something like http://www.screencast-o-matic.com/watch/cXnj1QIh4, which includes /watch/, rather than the URL from the editing screen, which contains /editscreencast/ instead of /watch/. A viewer who uses an edit screen URL will get a message that "You must be logged in as the owner of this screencast to edit" rather than access to the screencast.

You can set a password for access to the screencast if you have a high need for privacy. And, if you decide later that you would like to share the screencast

more widely, you can link to it (using the same URL you used for e-mail) or you can use the embed code to embed the screencast in another webpage.

► CREATE AN INDIVIDUAL TUTORIAL WITH AUDIO

Project 2 did not include any audio. In the example I created that is linked from the companion website (http://www.alatechsource.org/techset/), I did use the Screencast-O-Matic option to add notes to highlight the disappearing header, but it still relies on the viewer noting the error in the display. In general, screencasts with audio make for a much more engaging experience for the user, and it is much easier to communicate by explaining what you want the viewer to notice.

Fortunately, it is easy to add audio, as long as a microphone is available. Using the same approach and topic as in Project 2, this screencast will use Screencast-O-Matic, display the catalog errors that cause the missing header, include audio, and then be uploaded and hosted on YouTube for easier access.

Project 3	
Audience:	An individual catalog tech support
Software:	Screencast-O-Matic
Hosting:	YouTube
Topic:	Catalog Design Error Expanded

Expand the Click Path

The same click path used in Project 2 can be used here. Because this time an audio narration is included, the click path will be expanded to include notes about what to say at different steps along the way. In this example, audio notes are included as parenthetical notes. Not every step has one, because those steps should go by rather quickly and are not key to the point being made. The step is included as a reminder of where to click, but adding an audio note for each one would result in a longer than necessary recording.

1. Start in the library catalog (error occurs only on certain pages).
2. Click "DVD Search."
3. Search for "xtwain" (using a search term with no results).
4. Show missing header error (upper part of header including logo and branding is gone).
5. Click "OK" to show second example.
6. Search for "twain" (second example from an existing record).
7. Choose first record.
8. Click "Details."
9. Click "Catalog Record."

10. Click "InDigEnt" (this follow-up search has no additional records and produces error).
11. Show missing header error again (note that it is again only the upper part).

With this expanded click path, I am ready to rehearse once again and then record. Even though I made the other recording not too long ago, rehearsing the click path both double-checks that records (and error) have not changed and reminds me of the process.

Record with Audio

As with Project 2, I again set the browser window to a smaller size and then go to Screencast-O-Matic in a separate tab or window. To get started, I again click the "Start Recording" button in the upper-right corner. This brings up the recording frame, which I manage to make a slightly smaller size than last time (732×452). I then switch back to the catalog tab and check the microphone input. Clicking the down arrow by the microphone section lets me choose the headset microphone (and I plugged in the headset before clicking the Start Recording button to give the computer a chance to recognize the added microphone). After selecting the headset choice, click the green bar chart–like graphic to adjust the audio. Click the "Auto Adjust Volume" button, and then read something or just say something in a normal speaking voice into the microphone to have Screencast-O-Matic set an appropriate volume (see Figure 5.4).

▶ Figure 5.4: Setting Audio Volume in Screencast-O-Matic

Next, start the recording using the click path, and describe the steps along the way, paying particular attention to making the points in parentheses. If you trip over your tongue, accidentally stub your toe and start cursing, or just do not like the way it is going, click the "Restart" button to cancel the recording and start again.

Publish to YouTube

Once finished with the recording, you can still save to Screencast-O-Matic or download (Export) to your computer, but to get it to YouTube, just click the "Upload YouTube HD" link. (HD stands for "High Definition" and should provide a clearer and crisper video on YouTube.) Screencast-O-Matic gives a preview and choices for the YouTube title, description, tags, category, and other options, including Make private, Show mouse clicks, Show mouse halo, and Remove audio. After selecting the first three, enter your YouTube credentials and upload.

Compare this version, which has audio and is hosted on YouTube, to the previous screencast without audio hosted at Screencast-O-Matic. The audio track helps to explain the problem much more precisely, it is shorter in that I did not need to add additional highlighting as I did with the notes in the first example, and I think that it better communicates the catalog display problem. By hosting it at YouTube, it also bypasses the Java requirement for the viewers. YouTube even tries to find ways to display its hosted videos to devices such as the iPad and iPhone that do not support Flash. So, the YouTube hosting should make it much more accessible. The free Screencast-O-Matic account will put a Screencast-O-Matic logo watermark on the YouTube video, whereas Screencast-O-Matic Pro users will have no watermark.

Choosing the Make private option lets you share it just with other specified YouTube accountholders, and viewers must log in. An easier option for sharing is YouTube's Unlisted setting. This means that only people with the link can view the screencast, which means they do not need to log in and that video is not likely to be found by anyone other than those for whom it is intended. So, after uploading as private from Screencast-O-Matic, go into your account on YouTube, edit the video, and change the privacy setting to Unlisted.

▶ CREATE A QUICK DEMO FOR E-MAIL REFERENCE AND LIBRARY PROMOTION

In this project, a single screencast will serve multiple purposes. Created on Screenr with the intent of answering an e-mail reference question, it will also be

shared via Twitter for library promotion and to reach a larger audience. Similar to Project 1, this project expands beyond a single class as audience to using social media to reach a broader audience.

Project 4	
Audience:	An individual with an e-mail reference question and general library users
Software:	Screenr
Hosting:	Screenr
Topic:	Google Scholar Settings

Because many users may have interest in using Google Scholar while off-campus, this project is an ideal topic for marketing via Twitter.

Establish a Twitter Account

In the first project, you used an existing account at Twitter, Facebook, Google, Yahoo!, LinkedIn, or Windows Live ID to log in to Screenr. If you did not use a Twitter account and do not have one, you need to create one now. If you already have one but prefer not to use it for a project, just create a new Twitter account at twitter.com by filling out the three boxes on the homepage (name, e-mail, password) as shown in Figure 5.5. Confirm the account, and use it to log in to Screenr.

Outline the Click Path

Screenr works well for a question like ours, because the screencast will be recorded off-site, and you may not have access to the same commercial screencasting software that is available at the office. In this example I wanted to be off campus because Google Scholar shows default settings on campus that are different from off campus. Because Screenr is free, it works well for this situation.

▶ Figure 5.5: How to Establish a Twitter Account

In preparation for recording the screencast, the following outline shows the click path I plan to follow:

1. Begin at Google's homepage.
2. Go to Google Scholar.
3. Set Settings.
4. Search for "montana state" in Library Links.
5. Select "Check MSU Availability."
6. Scroll down to Bibliography Manager.
7. Show option for EndNote.
8. Save.
9. Demonstrate with search on "bozeman."

Run through a quick rehearsal of these steps, and resize the browser window to the minimum size that can still display the important information. In this case, the dimensions 650 × 396 work well.

Record and Share

As in Project 1, open a new browser window (with "Control-N"), and start Screenr. Be sure to log in with the Twitter account credentials, and then click "Start Recording." Resize the recording square to cover the browser content window. Record the screencast, following the click path steps, and give just a short verbal explanation of each step. End recording by pressing the "Done" button. When publishing, remember that a description is required, so be sure to fill it in before clicking the "Publish" button (see Figure 5.6).

Once publishing is complete, again look to the sharing options on the right-hand side of the screencast. To send an e-mail response to the individual who e-mailed about how to use Google Scholar from off campus, just include the direct URL within the response. Embedding a video within e-mail rarely works because most e-mail programs do not support embedding. Unless you

▶ Figure 5.6: Fill in the Required Description

Describe your screencast 112 characters left

Type an interesting description about your screencast

Publish! Delete screencast

have tested and know that the recipient can view an embedded video (and also know how to embed in your e-mail message), just send the link, and the recipient can view it in a web browser.

The Social links to Facebook and Twitter will post the Screenr URL to your Facebook Likes or create a Tweet using the description and adding the link. Because we have logged in with a Twitter account, it is easy to now post the screencast to Twitter. Just click the Tweet button. (If you logged in differently, a pop-up window will ask you to log in to your Twitter account. After logging in once, Screenr can remember your Twitter credentials and associate it with your Screenr account when you use a different Screenr credential to log in.) Before publishing the Tweet, Screenr gives you the option to edit the text, so you do not have to use the previous description; you can exclude the "Screenr—username" prefix, and you can even include the full URL or use a URL shortener.

Sharing the screencast via an organization's Twitter account achieves the secondary purpose of promoting the library services. If the library's website includes a section showing recent Twitter activity, the Tweet promotes twice: once on Twitter and again on the library's website.

Though not used in this project, note the additional options under More Actions. The .mp4 download creates a file that can be used for hosting on a separate website, uploaded to another hosting site, or saved as a backup. The Publish to YouTube option requires a YouTube account, which is explored in the next project.

▶ ADD CALLOUTS TO A SCREENCAST

Continuing with free options, and building on the previous project, we'll now add callouts to our screencast. Screencasting programs tend to label this function different (e.g., "text box," "overlay," "annotation," "caption"). I will use Camtasia's "callout" to describe this class of editing features, which create sticky notes, speech bubbles, thought bubbles, arrows with text, blurs, spotlight boxes, and other visuals

Project 5	
Audience:	Library Google Scholar users
Software:	Screenr
Hosting:	YouTube
Topic:	Google Scholar Settings

to label and draw attention to specific aspects of the screens. These are some of the most useful editing options for providing additional information and helping the viewer to get the key points of the screencast.

While most free screencasting programs have no editing capabilities, a few do, and in this example, combining the free, no-editing-option Screenr with YouTube hosting does let you add callouts to a screencast while using all free

services. You can add callouts to any YouTube-hosted video, even if you used another screencasting program to create it.

Host on YouTube

After recording and publishing a Screenr screencast, one of the More Actions is to Publish to YouTube. Log back into Screenr, and go to "My Screencasts" to find a list of saved recordings. Click on one of them, and then click the "Publish to YouTube" link. If you have not logged in with a Google account or previously input a YouTube username and password, you will be prompted for YouTube log-in information. No account? Go to YouTube and set one up or connect it to an existing Google account. Even with a Google account, if you have not connected that account with a YouTube account, you may need to go through that process first.

Once you have successfully established a YouTube account, just enter the username and password in the Screenr Publish to YouTube option to get the video uploaded to your YouTube account. While it will initially be made public, just log in to YouTube, go to "My Videos" (linked from the upper-right corner under your log-in name or directly at http://www.youtube.com/my_ videos), and Edit the newly uploaded Screenr video. Under Broadcasting and Sharing Options on the left are options for making it Private or Unlisted. Set it to one of those while you go through the Add Annotations process so that people do not view it until it is ready.

Add Annotations

In the tabs near the top is an Annotations section. Clicking on that will bring up the options for adding annotations, including choices for a variety of callouts (see Figure 5.7). Once the next page loads, the video starts playing right away. Pause the video, and then decide where to put the callouts. I like to start with one near the beginning that gives an abbreviated version of the main instructional point of the screencast. In the case of the previous Google Scholar screencast, I will use a callout of "Set your MSU options here" pointing to the Scholar Preferences link in the top right-hand corner.

After pausing the video, I move the control back to the start of the video and then click "Add annotation" on the right. As shown in Figure 5.8, YouTube gives five callout options: Speech bubble, Note, Title, Spotlight, and

▶ Figure 5.7: Adding Callouts

▶Figure 5.8: Customizing a Callout

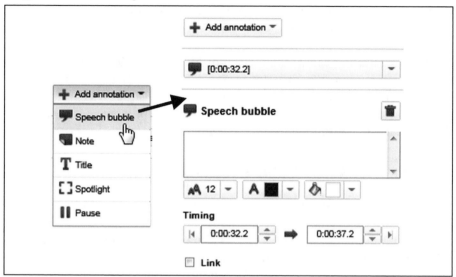

Pause. Choosing "Speech bubble" adds one to the video preview screen and presents the additional options shown in Figure 5.8: a box to enter the text, font size (only choices are 12, 15, and 18), font color, and background color. It seems to work best to first set the background color and then the font color. To change the position of the box, just click and drag it to the appropriate section of the screen. In this case, I move it to the upper-right corner, and then drag the handle on the speech bubble point so that it points directly at the Scholar Preferences.

The timing option can be used to set the duration, or just drag the edge of the icon on the timeline. Be sure to watch the video to figure out when the screen changes to the next page (once "Scholar Preferences" is clicked). You do not want to have the callout still on the screen when the screen changes, so set the duration accordingly. In this example, I could have it displayed for about eight seconds.

Note that YouTube shows an "Edit existing annotation" choice under the "Add annotation" button. This is empty if none has been added. Once one or more have been created, use this function for further editing of the callout as needed. You can change the colors, position on the timeline, and location on the screen, or you can even delete the callout if you find it is more distracting than helpful to the instructional goal.

Be sure to click "Publish" when done or the new callouts will not be saved. The other types of YouTube annotations have different settings. Experiment with each one to see how it works. The Note and Spotlight are similar to the

Speech bubble with different default settings. The Title has no background color option. The Pause is not really a callout, as it just extends a frame in the video, with no audio, for the duration specified.

While this combination of the free Screenr for recording and free YouTube for hosting can work, the callouts may not be viewable by all. I have had at least one report from a Mac user with a plug-in that converts YouTube videos to H.264, and for him the callouts are not visible. With the changes under way among competing video sites on the web, these are the types of discrepancies to continue to test.

► PRODUCE A BASIC DATABASE TUTORIAL

Jing is another free, downloadable screencasting program, and it works on both Windows and Macintosh computers. Jing comes from TechSmith, the maker of Camtasia Studio and Snagit. It also comes bundled with an account at Screencast.com for hosting up to 2 GB of screencasts (and 2 GB of bandwidth per month). It has an unusual interface, and I find a few students in my workshops who have tried Jing and find it to be very unintuitive, while others try it and take to it immediately.

Project 6

Audience:	Students
Software:	Jing
Hosting:	Screencast.com
Topic:	Music Online

This project shows how to create a basic database tutorial, with audio, and host it at a flexible hosting site. The topic is Alexander Street Press's Music Online database, which includes streaming audio, scores, and biographies. It is aimed at college students taking music courses.

Download and Install Jing

Jing is a software download, and must be installed on your computer. From http://www.techsmith.com/download/jing/ simply choose the appropriate version: Mac or Windows. After downloading, install Jing (in Windows, by double-clicking on or running jing_setup.exe). When the first setup screen is shown, click on "Options." By default, Jing plans to start up every time that the computer reboots. Deselect "Start Jing when the computer starts" unless you really want to have it running all the time. After clicking the "Accept the fine print" box, click "Install." You may need to have administrator privileges and/or allow the program to install. Once it installs, watch for a yellow ball (the Jing "sun") to float to the top of the screen.

Jing is driven primarily by icons rather than text. Mouse over the Jing sun and note the three icons that appear on the end of three rays. The one that looks like a plus sign is for starting capture (either video or just a screenshot).

The middle icon, which looks like two computer monitors, is the history tool (for seeing past captures). The third icon, on the right, looks like two gears and shows the mouse-over label of just "more." Check that one out first, as it gives access to yet more icons. From left to right: finish (or close the more options), send feedback, preferences, help, and exit Jing. The preferences (another gears icon) have a variety of settings.

During installation, or afterward by clicking on the gears "more" icon and then the gears "preferences" icon, you can either set up a new Screencast.com account or add your username and password for an existing account. Having this in the settings makes it easy to upload directly to Screencast.com.

Establish the Click Path

Now that Jing is installed, we can plan the content of this database tutorial. This screencast is designed to help music students understand the best way to search and use Music Online. Like many librarians, my typical failure with a project like this is to try and include too much in a brief video. Instead of trying to share everything that I have learned about the database, a better instructional strategy is to pick a few key points that can be shown quickly in a screencast and that are most likely to help new users of the database. My main points are how to find Music Online, use simple search strategies (unique words or combine composer and number), and explore audio quality settings and browse options. I want to record everything in less than two minutes (my usually maximum length goal for a screencast like this) with this click path:

1. Go to the library's homepage.
2. Go to Databases.
3. Go to Music.
4. Go to Music Online.
5. Search Unique: "pulcinella" (note that unique names are easier to find).
6. Identify audio (note inability to expand tracks in Internet Explorer).
7. Click to play.
8. Set high quality (but note that it may cause pauses in the audiostream).
9. Search for Haydn Piano Trio in E-flat using "haydn 31."
10. Note biography from All Music Guide.
11. Show browse dropdown menu and filters on right.

Record with Jing

Once the click path is established, run through the whole thing once or twice to make sure the examples work and to note where the windows pop up. The

audio player in Music Online is a small pop-up window, and you need to know if it will be in the recording area. If not, you have a couple options. You can start it before you record and position it behind the main browser window. Then, when you get to that part of the recording, pause Jing, switch to the pop-up player, and position it within the recording rectangle. Then start up Jing again and continue. Or, you can plan to move the pop-up window back into the recording window quickly when it appears. Fortunately for me, the player pop-up window displayed within the recording window except for the very top of it, which just had the browser identification information, so I left it where it was.

Once the browser is positioned, mouse over the Jing sun and click on the plus icon. Then mouse over the browser window, and Jing can automatically select the area within the window with a single click. Select the appropriate window, or create your own recording area. The menu bar appears, and the two choices on the left are for Capture Image and Capture Video. Choose the second to record a screencast (see Figure 5.9). Jing gives you a three-second countdown to prepare and then starts recording both the screen and audio from your microphone. Function buttons appear below the recording area. The first three from the left are the most important: the solid square ends the recording; the two vertical lines is a pause button; and the microphone is

▶ Figure 5.9: Recording Options in Jing

the mute button. On the far right, the circled X is a cancel button. If you start and make a mistake or just do not like how it is going, click to discard and then start over again.

I like to rehearse at least once using the software. In this case, I found on the first run-through that I took almost three minutes to complete the outline. I also had accidentally muted the microphone, so I just discarded that recording as soon as I finished. How can I shorten the video? I saw that I had taken over 20 seconds just to get into the database. In the next run-through I aimed to accomplish that in less than five seconds, and I dropped the comment in step 6 about the inability to expand tracks because it was not crucial to the instructional points. These two changes helped me to reduce the time to 2 minutes, 19 seconds, which was close enough to my goal (and I hoped short enough for students so that they might watch it all the way through). Also, remember Jing's limitation to a five-minute maximum recording length—another good reason to keep it short and succinct.

Host at Screencast.com and Embed in a LibGuide

After the screencast is recorded, Jing displays the recording in a yellow-bordered window. Play at least the beginning to make sure the sound is good enough quality, or watch and listen to the whole thing. Again, if you do not like it, click the circled X to discard and start again. If it is good enough, then look at the other icons on the bottom. The Name line defaults to date and time. Change that to something meaningful so that you can recognize the video later. Underneath the Name box are more buttons with icons (seeing a trend here?). Just mouse over to see what each does. The first is the Share via Screencast.com. Click that to automatically upload the video to your Screencast.com account (see Figure 5.10). It will be placed in your Jing folder. When it is done, a message is displayed that your video has been uploaded and is ready to share. The link has automatically been put in your

▶ Figure 5.10: Share via Screencast.com

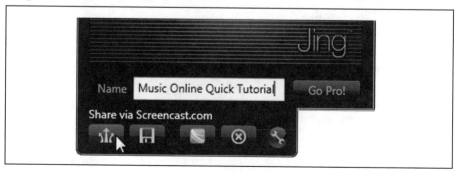

clipboard buffer, so you can quickly paste that link in an e-mail, to a blog post, or on another webpage.

Screencast.com also supports embedding the video. If you have access to LibGuides or direct access to webpages on your library server or some other online platform that supports embedding, start by going to the link at Screencast.com. Below the video, click the "Show Details" button, and then click on the "Share" tab. Like many Web 2.0–style content hosting sites, Screencast.com provides embed code that can be used on other webpages or blogs. For inclusion in a LibGuide, I just copy the embed code.

Before we proceed, note the importance of sizing the columns to be able to accommodate the tutorial. In this case, the video is 768 pixels wide (which is shown near the beginning of the embed code, which starts with <object id="scPlayer" width="768"). The standard LibGuide layout uses three columns, with the largest in the center at only 520 pixels wide. Insert a large video object, and it will bleed over the edges into another column. A two-column layout only gets as wide as 758 pixels, with margins reducing the available space to about 740 pixels, so I change this page to a single-column layout at 975 pixels wide, which will easily accommodate the embedded screencast. Those who use LibGuides would do well to try to keep the widths of their recordings at 740 or less for a two-column layout and less than 500 for a three-column layout.

I followed these steps to embed the video in a LibGuide:

1. Log in to the LibGuide account.
2. Open the music guide (in the dropdown menu for "Edit Existing Guide").
3. Click "Add/Edit Pages" in the Admin bar at the top.
4. Click "Add/Reuse Page."
5. Title it "Music Online."
6. Click "Create Page" to save.
7. Click "Add/Edit Pages" again.
8. Click "Resize Columns" and change to a "Center Column Only" of 0,975,0 pixels.
9. Click "Add New Box."
10. Choose type: "Embedded Media & Widgets."
11. Title it "Quick Tutorial."
12. Edit text at top with a brief description.
13. Click "Edit Media/Widget code," and paste the embed code from Screencast.com.
14. Save changes, and the new database tutorial is live.

The bulk of my time spent on this project was in planning the content of the tutorial. The recording took less than 15 minutes (counting several false

starts and run-throughs). Uploading to Screencast.com took only a minute or two. Creating the LibGuide page and embedding the screencast took less than 10 minutes. This project is an example of how to create a quick online tutorial and make it live in less than 30 minutes.

▶ CREATE A SCREENCAST FOR A BLOG POST

Further exploring with Jing, here is an example from a blog post that I created in May 2011. Google News had new settings that were available only to signed-in users and provided the ability to look up indexed titles in Google News. I wanted to describe these issues and show how the new Google News settings could be changed. Because it was not immediately intuitive to me where the settings were located, and it would be difficult to explain in writing how to look up the indexed titles, this topic seemed perfect for a blog post with an embedded screencast to show how to use the settings and look up titles.

Project 7	
Audience:	Blog readers
Software:	Jing
Hosting:	Screencast.com and Movable Type Blog
Topic:	Google News Settings

Plan the Screencast

After reading in other blogs about the discovery of new search settings in Google News, the first step is to explore the new features to see how they work and whether or not there is anything interesting to share and report on my own blog. After some researching, I realized that I had several comments to make about the changes and that a screencast would demonstrate what I wanted better than simple text and screenshots. Thus, I developed the following click path to demonstrate a few key discoveries:

1. Start at Google News, not signed in.
2. Click the gear icon to show settings options.
3. Log in (pause recording).
4. Show news home settings (a few seconds).
5. Explain blog and press release options.
6. Show tab with press release examples.
7. Show tab with blog examples and limit.
8. Demonstrate Publication Preferences:
 a. Add NYT, LA Times, American Libraries.
 b. Show Search Engine Land variants.
9. Discuss use as a source look-up.

For me, as a screencaster who is used to using editing software, when I switch to using something like Jing with no postproduction editing capability, I find that I often toss out my first few recordings. The basic process is to plan the click path, run a quick rehearsal, record, and then review the recording. I tend to get overly picky at times, and I find a few wordings that I did not like or notice that I took too long at the beginning talking rather than showing. So, consider what can be improved, make notes about those items, delete the first recording(s), and just try again. After a few iterations you should find the video improving, and fine-tuning the instructional intent will help viewers as well.

Screencast.com Hosting Decision

At the end, I again uploaded the resulting video to Screencast.com. The bandwidth limits of the free Screencast.com mean that users should consider the potential popularity of a screencast and have back-up plans in case the video becomes so popular that the bandwidth limit is reached. At that point, the screencast becomes unavailable.

This happened to me several years ago with one screencast on Screencast .com, back when the free bandwidth limit was even lower than it is today. That particular screencast was viewed enough times that all the bandwidth had been used up, and none of my other Screencast.com-hosted videos would be viewable until the next month (unless I paid extra for a Pro account).

After that experience, I have primarily used Screencast.com for hosting limited-audience videos rather than more public ones. Why post this one to Screencast.com? I have actually posted several there recently. It helps make the embedding a bit easier and less time-consuming. Plus, blog entry interest is typically of limited duration. The main viewership usually peaks within a few days of posting and then declines to almost nothing. For this particular topic, I expected only limited interest from a few other search geek types. Also, because of its width dimension, the video is buried a bit deeper than the rest of the post and thus is less likely to be viewed. However, because I am cheap and not paying the $100/year for 100 times the monthly bandwidth of Screencast.com Pro, I checked my account every few days to make sure that I was not getting too close to the cap. After logging in, just click "My Account," and check the bandwidth and storage usage as shown in Figure 5.11.

Embed in a Movable Type Blog

The process to embed the video from Screencast.com into my blog is an easy process (or not) depending on the blogging software, hosting location, site

▶ Figure 5.11: Monitor Bandwidth Availability

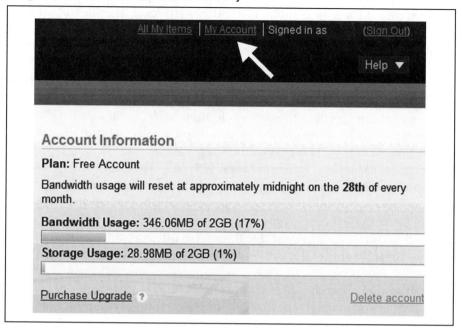

design, and the width of the video. These issues hold true for blogs and other types of content management system (CMS) software. Blogs hosted on your own server are more likely than cloud hosted ones to support embedded Flash videos. Blogger allows some embedding, but it is more variable with WordPress. For example, it is possible to embed Flash on a local installation of WordPress, but it is not allowed at the community WordPress .com site (see http://en.support.wordpress.com/code/). WordPress.com can embed videos from YouTube and some other platforms but not directly from Screencast .com (although there are some workarounds).

On all blogging and CMS systems, and even on static webpages, the screencast width should be a major consideration. In Project 6, the screencast width necessitated a single-column layout in a LibGuide so that the entire screencast would fit and be viewable. If a blog, CMS, or website template has a maximum width on some pages, the screencast needs to be narrower than that maximum to avoid spillover or invisible content. The height also makes a difference, and a too-short container can obscure the controls, but width is more often the problem than height because most layouts do not have a maximum height defined.

For my *SearchEngineShowdown* blog, my three-column design limits the width of an embedded screencast. The homepage and main blog page both

use three columns (which may well have changed by the time this book is published, but for now it limits the width). However, the individual blog entries are in a two-column layout, so more room is available there for an embedded screencast. On the three-column layout, I have up to about 500 pixels available for the maximum width, but on the two-column layout I have up to 685 pixels available. So, I just link to a larger screencast. For less than 500-pixel-width screencasts, I include those in the main part of the post because they can fit within the three-column layout. I include 500–685-pixel-wide screencasts in the extended blog body section, which will display only on the two-column, full blog post entry page.

SearchEngineShowdown is run on Movable Type (locally installed on my own web server), but the embedding process and issues are similar at many other blogs and CMSs. The initial blog post edit screen is a box with some WYSIWYG editing tools. Embed code from Screencast.com is code that works best when inserted within a code view. Movable Type offers several editor format options: None, Convert Line Breaks, Markdown, Markdown with SmartyPants, Rich Text, and Textile2. I typically use a combination, starting my text composition in Rich Text. Because I want the screencast to appear only on the entry page (two-column), after writing the beginning of the post, I click on the "Extended" tab to get to the section for pasting the embed code. Then, I click on the "<A>" icon for HTML mode editing, and paste the Screencast .com embed code. I also find that with the transition from Rich Text to HTML mode (or any of the other editor formats), some paragraphs do not display correctly or need to be cleaned up. So, I removed double line breaks and replaced with paragraph tabs. Also, the blog style uses indented paragraphs, so the embedded screencast also gets indented, which can make it shift too far to the right. To accommodate this (still in HTML mode), I added an inline CSS style declaration to correct that indent (in this case, <p style="text-indent: 0;">).

Because there are so many options that could be missed, incomplete code could be pasted, or style sheets could override other formatting, be sure to check the embedding as soon as it is posted in case further changes are needed. Also, if the blog has an RSS feed (which almost all blogs do), check how it displays within the RSS feed. Videos can be included in an RSS using an <enclosure> element, but not all feeds are set up to do so. If yours are not and tech support cannot set this up for you, consider language that might link to a hosted version of the screencast for those reading the RSS feed and that would also work for those reading the blog version with an embedded video (perhaps something like "see the screencast below or the hosted version..." with a link from "hosted version" to the screencast).

▶ MAKE A CLASS ASSIGNMENT TUTORIAL

Camtasia Studio is one of the market leaders and has a huge collection of features and capabilities for recording, editing, and producing screencasts. This commercial, and very powerful, program has so many options that there could be a whole book on it (and there is—Park's 2010 e-book *Camtasia Studio 7*). Project 9 will explore more of the power features and editing capabilities, but first Project 8 will demonstrate how to use the basic features of Camtasia Studio to record and upload a screencast.

Consider a history class that has an assignment to find historical newspaper

Project 8	
Audience:	History students
Software:	Camtasia Studio
Hosting:	YouTube
Topic:	LC Historic Newspapers

articles from a particular place and time period. In this example, the assignment is to find an article from a Miles City, Montana, newspaper from 1885, available via the Library of Congress's Historic Newspapers online collection. As part of a library instruction session, this screencast will show how to get to the newspapers and how to use the interface to zoom and pan across the papers to find an article for the assignment. Because this is a basic show and tell, only a few of Camtasia Studio's features will be used, but it is a good introduction to using the basics.

Download Camtasia Studio

To start, download a free trial copy of Camtasia Studio. The 30-day trial is full featured, so plan to do this when you have some time to explore the software. Go to http://www.techsmith.com/download/camtasia/ to download the trial. All that the company asks for is your e-mail address (and they state that "We will not share your email address with anyone, period"). After downloading Camtasia Studio, install the software. (The following directions are based on the Windows version. Adapt as needed for a Mac installation.)

Accept the license agreement, and choose whether or not to participate in the usage data collection. Then choose the 30-day evaluation (unless you have already purchased a key), and click "Next." Note that if you have PowerPoint on your computer you can install the Camtasia Studio PowerPoint add-in, which lets you record a PowerPoint presentation with audio and turn that into a screencast. If you choose to install the add-in, it will show up when you start or run PowerPoint. If you are ready to try it out right after installation, check "Start Camtasia Studio 7 after installation." You may need admin privileges or have to give the program permission to continue to be able to install the software. After installation of the trial, each time Camtasia Studio starts, it will show a countdown for how many days remain of the trial. Click

"Finish" to begin using the trial. Camtasia Studio will start in the editing window with a five-minute preloaded screencast that shows the basics of how to use the editor.

Plan the Outline and the Click Path

While downloading the software or before (or after), plan out the click path for this project. In this case, I start with the Library of Congress homepage:

1. Go to Library of Congress homepage.
2. Click "Historic Newspapers."
3. Click "All Digitized Newspapers."
4. Change state to Montana and click "Go."
5. Choose the Miles City newspaper, and click the Browse Issues icon.
6. Change "Issues for" date to 1885.
7. Pick a sample day (near birthday).
8. Show Navigation: Zoom, Pan, Drag.
9. Show Clipping Tool (note it clips what is displayed on the screen).

In rehearsing this click path I notice that because the navigation of the actual newspaper scans can be difficult, I spend more time trying to explain that part. As a result, I expand that section of the original click path and add more notes. This should end up reducing the total time of the recording by planning more carefully what to say about the navigation and clipping functions.

Explore Camtasia Recorder Options

After the first time starting Camtasia Studio (when it defaults to the Getting Started screencast), the Welcome screen provides several choices: Record the screen, Record voice narration, Record PowerPoint, and Import media. It will also show recent projects and a link to the TechSmith Learning Center, which has lots of screencasts about how to use Camtasia Studio. I have Camtasia Studio always show the Welcome screen, because it provides quick access to start recording. The window behind the Welcome screen is the Camtasia Studio editing screen that we will explore later.

To get started, make sure the browser with the Library of Congress home-page is ready and sized as small as will work for this example. In case I decide to embed the video in a LibGuide, I make sure to keep the width less than 750 pixels. Then, to start the recording process with Camtasia Studio, click the "Record the screen" button. The default is Full screen, so click the "Custom" button to record the smaller area. Move the mouse over the browser window to select that area, and note the dimensions (as I am aiming

to keep this less than 750 pixels wide). To record just the video and an audio narration, make sure that the audio is on (under "Recorded inputs") and that the webcam (if you have one) is off. After clicking the "Audio" button on, click the dropdown arrow to check that the correct microphone is chosen. Speak in a normal voice into the microphone, and make sure that you see the green bar moving to the right of the "Audio" button. That means that the microphone is live. Adjust the volume as needed.

Click "Record," and, like Jing, Camtasia Studio gives a 3-second countdown before starting. Note that it also tells you that you can use the F10 key to close or stop the recording. F9 is used to start and to pause the recording. The toolbar below the recording windows also has buttons for these functions and continues to show the audio meter as well as a large timer that indicates the duration of your recording. For this project, I went longer than I usually prefer, with 3 minutes, 30 seconds for the total. Rather than rerecording and trying to get it shorter, I can use the Camtasia Studio editing capability to cut out dead sections of the timeline or whole segments if I decide I do not need them.

After finishing the recording, a Preview window appears with the recorded video. I can listen to it to make sure it is ready for editing, or just click the "Delete" button if I wish to discard it and start over. Generally I use the "Save and Edit" button, which brings the video into the editing window. We will do that in the next project, but for now, because I am going to leave this video as originally recorded in the interest of time (for example, if I had been asked to create one just a half hour before the library instruction session). I will instead click the "Produce" button to quickly make the screencast available.

Produce and Host on YouTube

After clicking "Produce," the first step is to save the video file on the local computer. You can put it in the default directory but may wish to give it a more meaningful name instead of the default. For example, instead of "camrec1.camrec" I used "history-class.camrec" (".camrec" is the Camtasia recording format). After saving the file, Camtasia Studio then pops up the Production Wizard. The Wizard has a wide variety of preset production choices:

- ▶ Blog
- ▶ CD
- ▶ DVD-Ready
- ▶ HD (High Definition video)
- ▶ iPad
- ▶ iPhone
- ▶ iPod
- ▶ Web
- ▶ Custom Production Setting
- ▶ Share to Screencast.com
- ▶ Share to YouTube

You can also create additional presets or edit the ones listed. Choosing "Share to YouTube" and then clicking "Next" takes you to a screen for entering your YouTube username and password. Click the "Remember Me" box to make YouTube upload even faster in the future. Click "Next" again for a screen with the YouTube production choices of Title, Description, Tags, Category, and Privacy. Privacy has only "Share with the world" and "Private" options, so, to set a video to unlisted, choose one of the other settings and then change to unlisted from YouTube.

Click "Finish" to produce and send to YouTube. It will take a few minutes to render the project, depending on the speed of your computer, and then it will upload to YouTube automatically. At the end, it brings up a YouTube page that says the video is being processed. To share with the class, I can just add the YouTube link to a class page or handout or use the YouTube embed code to place the video in a LibGuide or webpage.

This project used the very basic features of Camtasia Studio, similar to some of the free, no-editing screencast recorders. The next project explores taking the same video and using some simple editing functions to improve it.

►EDIT SCREENCASTS (CAMTASIA TIMELINE, AUDIO, AND CALLOUTS)

Continuing with the same recording from the last project, we will now look at how to place the recording into the Camtasia Studio editing window, perform some simple edits, and then publish it directly to a library web server.

Project 9

Audience:	History students
Software:	Camtasia Studio
Hosting:	Library Web Server
Topic:	LC Historic Newspapers Follow-Up

One of the first things I noticed in reviewing the recording was that the sound quality was not as clean as I had hoped, primarily because of some background white noise. I could have lowered the input volume on the microphone and rerecorded it, but I thought that it was not bad enough to worry about for a simple and quick screencast production.

Camtasia Studio Editing Window

It helps to understand the three parts of the Camtasia Studio editing window (see Figure 5.12). The Timeline section at the bottom of the screen is used to assemble and edit the video with various timeline functions such as undo, redo, cut, copy, paste, split, and zoom. You can zoom in for precision editing, cut segments, and undo previous edits. The timeline consists of separate

▶Figure 5.12: Camtasia Studio Editing Window

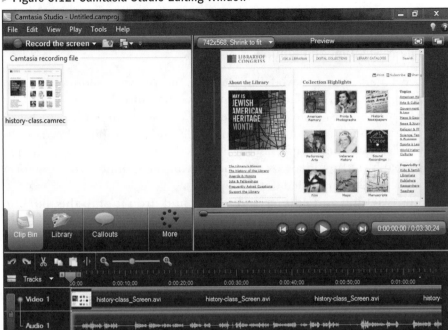

tracks as needed for video, audio, zoom, callouts, cursor, quiz, and more. To select a portion of the timeline in Camtasia Studio versions 6 and earlier, just click and drag the playhead to select the appropriate portion. With version 7, the green and pink handles on either side of the playhead are moved to select a portion of the timeline. Double click the playhead to bring the handles back together.

The upper-left pane, with a white background, starts out as the Clip Bin, which holds various media used in the current project (although it may just include a single .camrec file, the recorded video file). Click the other tabs at the bottom to change the options in the Clip Bin area. The Library contains reusable media. The Callouts, Zoom-n-Pan, Audio, Transitions, and other options under More will be explored more deeply in this project and the following one. Above the Clip Bin are three important buttons: Record the Screen, Import Media, and Produce and Share. The Record is used to start recording, and the Produce is for creating various versions of the finished product.

The upper-right pane is the Preview window. The resulting video is viewable here, even as you edit. The video also includes any special features that have been added so that you can preview the zooms, callouts, and audio changes.

Icons in the upper-right hand corner can make the preview full screen or even float as a detached window.

Timeline Navigation and Editing

Because I had already saved the .camrec file before producing it and uploading it to YouTube, it is easy to pull that file into Camtasia Studio for editing. In Windows, I can just double click on the .camrec file, which will start up Camtasia Studio with the .camrec file in the Clip Bin. Alternatively, start up Camtasia Studio and choose "Import Media." Browse to your .camrec file (probably in the Videos section, possibly in the Camtasia subdirectory) and select it to have it added to the Clip Bin.

To start viewing and editing it, just drag and drop it onto the timeline located in the lower part of the Camtasia Studio editing window. An Editing Dimensions box will appear with many dropdown choices along with advice about the dimensions to choose. The automatic dimensions setting keeps the aspect ratio but reduces the size to fit within a 640 × 480 pixel rectangle. Reducing (or enlarging) video with textual content will cause the text to get distorted and potentially make it more difficult to read. How much text is in the video (and how important readability of that text is to the instructional point) can help you determine how much distortion is acceptable. Or choose the original "recording dimensions" for best readability. If you later decide to change the editing dimensions, click on the upper-left button in the preview box and choose "Editing Dimensions" to get back to all those choices. I kept the original recording dimensions and can now start editing.

To make the video shorter, my first step is to go through and start cutting out some sections. I tend to wait too long at the beginning of the recording before I start speaking. In this example, I waited about 2 seconds. Nothing happens then, so I select the opening silent time by keeping the playhead (and green handle) at the very beginning of the timeline and dragging the red handle to just before where the audio squiggles start. I then click "Play" in the Preview window to make sure that I do not have any speaking within that section, and then click the scissors icon to cut the opening. I again click "Play" in the Preview window again to see if I like the opening without the pause. If I decide that it works better with a shorter pause, I click the undo key (or press "Control-Z") and cut a shorter segment.

I continue playing through the video and cut any other segments with long pauses, especially when I am just waiting for the next page to load. Sometimes I also cut extraneous comments, especially if there is not video action and the comment is not crucial to the instructional objective. I spent

almost 25 seconds in the original discussing the optical character recognition problems in the scanning, so I cut that out. After going through all of this cutting, I managed to reduce the video from 3 minutes, 30 seconds to less than 2 minutes, 20 seconds without losing any of the instructional objectives.

Cursor Effects

Before Camtasia Studio 7, the Cursor Effects could be added only at the recording stage and could not be changed in the editing process. The effects are still available as recorder options, but with version 7 it is much easier to add these after recording and just where they are needed or to the whole timeline. Cursor Effects include highlighting the cursor location, highlighting either right or left (or both) mouse clicks, and adding sound effects to emphasize the mouse clicks.

Click on "More" (beneath the Clip Bin) and choose "Cursor Effects." Note that you can make the mouse cursor visible or not. For this project, I checked the mouse cursor visible box and added the Highlight Effect "Rings" for the Left-Click Effect and the "Laptop Click" for the Left-Click Sound Effect.

The effects help to keep the viewers' attention on what you might be pointing out with the mouse cursor and make it clear when something is clicked. With the greater editing capability, you can now add key frames to start and then stop certain effects on the timeline. These are added to the Cursor track. In this project, I turned off the highlighting at the end.

Because I am in the habit, from in-person interactions, of using the mouse cursor to point out items on the screen, I tend to have the highlighting turned on. If, however, you tend to randomly move the mouse with no connection to where you plan to click next, it is best to leave off the highlighting and consider making the cursor invisible.

Audio Editing

Because the audio background noise was somewhat bothersome, that is the next change to make. First I click on the "Play" button in the Preview pane to double-check the audio quality. The background white noise is still there, so I click the "Audio" button (just above the timeline). Several settings are available: Enable Volume Leveling, Enable Noise Removal, and Enable Voice Optimization. Camtasia Studio tries to automate many tasks. In this case, just a single click on "Enable Noise Removal" causes Camtasia Studio to identify a section on the timeline without voice, identify background white noise, and then automatically remove that white noise from the whole track.

Listen to the result to make sure it accomplishes the objective. In this case it did just what I wanted. If it somehow made it worse, just uncheck the noise removal box, and it goes back to the original soundtrack. I have had most success with the noise removal option and less success with the others, but try them with your recorded voice to see which options work best for you.

Other audio editing options include volume down, volume up, fade in, fade out, and silence. If you accidentally recorded the whole track too loud or too soft, click "Volume Down" or "Volume Up" to adjust as appropriate. For the other three, you first need to select the part of the timeline to which the adjustment would be provided. Of the three, I have primarily used the silence tool. For example, if I drop something while recording so that I end up with a crash in the audio, I just find that part on the timeline, select the beginning and end of it, and click the "Silence" button. This way the video is not cut, but the crash is removed. If the crash happened while I was talking, I would also lose those words, so this works best on accidental noises between words.

For this video, I take some extra editing time to remove some extraneous noise between words. I tend to inhale too loudly, and it becomes audible in screencasts. Although it does not seem to bother most listeners (or at least those who I have asked), I sometimes take a little time to clean it up. To do so, I just select the part of the timeline where the only sound is me breathing in (being especially sure not to cut off the beginning or end of a word) and then replace that section of the audio track with the silence tool. I use the zoom slider to make it easier to identify the beginning and end of words or phrases on the audio track of the timeline. After each replacement of breathing with silence, I then replay from a few seconds earlier to make sure that the words still flow. While I could just cut out the entire video during the inhale time, the screen often has motion, and cutting the video as well would make the screen motion choppy. I also find that having some brief silent times helps the listener absorb what is said and helps avoid making the screencast seem too rushed.

Callouts

As seen in Projects 4 and 5, callouts can highlight key instructional points. Callouts also expand the ways a screencast helps viewers learn. A screencast already has audio and video that both tell and show the lesson. The addition of callouts adds another visual element that contains just a few words to reinforce what is being seen. In addition, if the viewer has turned the sound off, callouts can still convey the key points of the audio track.

For this project, I will add callouts for all the click path points. I will also use a different style of callout for each one. In general it is better to have more

consistency and change the callout type only for an instructional reason. But for this example, my intent is to show a few examples from the wide range of callouts available in Camtasia Studio. Sometimes, callout types are labeled at the bottom of the callout (Thought Bubble, Arrow, and Highlight are just a few examples).

To start, move the playhead back to the beginning of the timeline (or start a few seconds into the clip so that the callout has time to fade in and can reemphasize what you just said in the narration). In the Clip Bin area, click the "Callouts" tab at the bottom. Then click "Add Callout," and select a shape from the long list of preset callouts. The chosen shape appears in the Preview pane and can be dragged to resize and reposition it. Then add the text in the box in the Clip Bin area, noting that you can choose your font, color, justification, and size. The default fade-in and fade-out times are one second each, but they can be adjusted. After creating the callout, check the duration to make sure it does not stay on the screen after the video moves away from whatever it is highlighting. Just go to the callout track on the timeline and adjust the beginning or end of the callout to match the video movement (see Figure 5.13).

▶ Figure 5.13: Callout Options

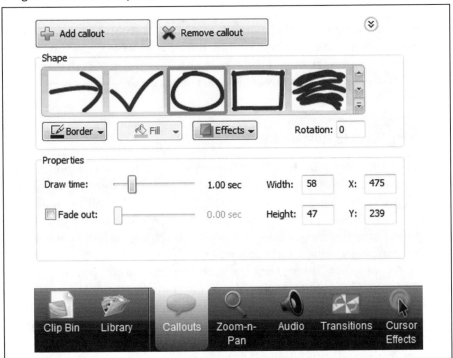

Another callout is the Spotlight highlight, and it dims the rest of the screen, thus drawing attention to the selected area. A Spotlight does not support text within it, so this callout is not labeled. Because it also has little time to appear before the next page displays, I removed the fade-out from that callout. The Pointy Arrow callout has yellow drag dots for rotating it and changing the arrow head size. The next time I use an arrow, it remembers the color, font, and even position of the previous one. Instead, I next use a Sketch Motion Arrow followed by a Sketch Motion Oval (neither of which allow labels). Instead of a fade-in time, the Sketch Motion callouts have a Draw Time selection at the beginning because they are drawn on the video. You can change the color of Sketch Motion callouts but not much else.

At the very end I added another specialized callout function. Most callouts can be turned into a Flash hotspot. In other words, the hotspot adds a very simple level of interactivity. Viewers who click on a hotspot can go to a particular frame of the screencast or jump to a specified URL. A Flash hotspot can be used as a way to make a "Click to Continue" button. In this case, I turned a final callout that displayed at the end of the video into a hotspot that takes the viewer to the Library of Congress's website (and set it to "Open URL in new browser window" so that the screencast stays available as well). For some reason I had difficulty at first getting that callout to remain visible all the way to the end of the video until I zoomed in on the timeline so that I could drag the end of the callout all the way to the end of the timeline. Note that if you create a Flash hotspot or quiz or use any other Flash interactivity, it will work only if the screencast is hosted on a web server or a hosting platform that supports Flash (Screencast.com supports some but not all).

Producing Flash to Host on a Web Server

With all of this editing finished, do make sure that you have saved the Camtasia Studio project. Editing does not change the original video recording file. Instead, a separate file (.camproj format) keeps record of all the editing to apply to the published project. With a saved project, if you later decide you added too many special features or just need to change a part of it, you can open up the project again and easily make the change.

Once the project is saved, click the "Produce and Share" button near the top. Because a Flash element was added, Camtasia Studio defaults to a web preset production setting. Choose that and then give the produced file a name (which will be part of the URL, so it is wise to name it based on the topic), and pick a folder on the computer in which to save it. I also checked the "Organize Produced Files into Sub-Folders," "Show Production Results,"

and "Play Video after Production" as ways to help me keep the screencasts organized and verify that the rendering worked correctly. Then click "Finish."

Again, it can take a few minutes to render, depending on the length of the video. Once it is finished, a Production Is Complete screen should be displayed that lists the file location, the number of files produced (six in this case), the content size and duration, the video dimensions, and a button to open the production folder. Note that these produced files are available only on your computer after production. The files need to be transferred to a web server and linked from another page to be made available to viewers. In this case, I click on the open production folder button so that I can open the generated HTML file to make a few edits.

Camtasia Studio by default creates an HTML page with the title of "Created by Camtasia Studio 7." Although many users never change that title (a Google search on intitle:"Created by Camtasia Studio 7" finds thousands of pages with that title), it is easy to change and tie the page content into the rest of your site. You can add a header and footer or at least links back to your homepage.

In this case, I changed the HTML title and added a visible H3 title below the video along with a few links including one to the unedited Project 7 version hosted at YouTube. After saving the edited version, I also changed the name to "index.html" so that I can create a shorter URL (by leaving off the file name). From my office, I can use Windows Explorer to just copy the whole directory into my personal web space on the server. Depending on your connection to your web server, you might need to use an FTP client, an SFTP client, or some other type of connection to transfer the files. In some libraries, you might have to get all the files in the directory to a web support person and hope he or she will load it. Ideally you have easy and direct access to place the files on a server. Once the files have been transferred, check the video in a web browser to make sure it plays correctly. If not, some of the files may not have transferred correctly. The Flash link at the end works because this is being served up as Flash.

▶ CREATE SCREENCASTS WITH MORE SPECIAL FEATURES USING CAMTASIA STUDIO

On our campus, most EndNote and EndNote Web users are graduate students and faculty. One frequent difficulty is explaining the various ways to get citations from a bibliographic database

Project 10

Audience:	Graduate students/faculty
Software:	Camtasia Studio
Hosting:	Personal web server
Topic:	EndNote Web: Importing Records

into EndNote Web. Database-by-database instructions can help, if people can figure out which one to use and when (and know where to find the instructions).

This project is aimed at showing how it is done for several databases. Because I am also showing several Camtasia Studio features and permutations, it is not a production version, but it will help us explore more special features from Camtasia Studio.

This click path is less detailed, as I plan to make changes as I go, especially so that I can include some Camtasia features for demonstration purposes, even though they may not add much to the instructional purpose:

1. Enable webcam.
2. Log in to EndNote Web.
3. Go to library website.
4. Search in CatSearch:
 a. Save to folder.
 b. Open folder.
 c. Export.
 d. Switch to EndNote Web.
 e. Import.
 f. Find file.
 g. Choose "RefMan RIS."
 h. Import.
5. Search PsycInfo:
 a. Mark results.
 b. Save/Print/E-mail.
 c. Save.
 d. Switch to EndNote Web.
 e. Find file.
 f. Choose "PsycInfo (CSA)."
 g. Import.

Picture in a Picture

Because one feature to be shown in this project is the Picture in a Picture (PIP) overlay video, before starting to record, we need to enable the webcam. Once the Camtasia Recorder starts up, make sure both audio and webcam are turned on (and that the webcam picture is viewable and the audio register shows that the microphone is picking up sound). In this project, I also selected a larger window size so that I could demonstrate the SmartFocus Zoom and Pan features.

After ending the recording and choosing to "Save and Edit" the video, Camtasia asks where to place the PIP preview placement. Note that the floating window option can be produced only as a Flash file, which means that if you plan to upload to a video sharing site like YouTube or Vimeo you should choose to preview the PIP on top of the video track. When Camtasia Studio prompts for choosing the editing dimensions, accept the default automatic dimensions to be able to effectively use the SmartFocus Zoom and Pan features (also being sure to maintain the aspect ratio).

Notice on the timeline that there is a Video 1 track, a PIP track, and a PIP Audio track. The webcam recording is on the PIP track, and the audio is actually tied to that rather than to the Video 1 track. In the Preview pane, just click on the PIP window to move or resize it; it will stay in one position throughout. Also note that when you click on the PIP window, the Clip Bin pane changes to the PIP properties. This is where you can set the opacity (how see-through it is), add a border or a drop shadow, and choose when to show and when to hide the PIP. The PIP manager allows you to remove the clip (but it also removes the audio).

When the PIP feature was first introduced in Camtasia Studio and other screencasting software several years ago, most librarians with whom I discussed it saw no need for such a feature. However, in recent years, I am hearing more people who want to include a librarian's talking head so that the students can have a face to recognize (Steeleworthy, 2010). It does not need to be on the screen for the entire video but can be shown for just a while, as in the example in the project. The PIP can also be used for other video and not just as a talking head. It could show zoomed-in examples or context on the larger page or some humorous unrelated video clip. If no PIP is recorded initially (or on parts of the timeline without a PIP), a second video can be added as a PIP by just dragging it to the timeline from the Clip Bin.

Zoom and Pan

Zooming into the part of the screen where the action is occurring serves two instructional functions: it lets viewers see where on the overall screen the action area is located and then clearly displays the action area well enough so that the details can be seen. "Pan" is another name for "zoom out." Camtasia Studio has a SmartFocus setting in its Zoom and Pan area that tries to automatically track where the action happens during your recording and then zooms in on those parts. It is designed to help with large full-screen recordings that need to be produced in smaller dimensions for a blog or section of a webpage.

If the clip is large enough and the default editing dimensions are accepted, Camtasia Studio defaults to applying SmartFocus when the video is first added to the timeline. This default can be changed under Tools/Options/Zoom. If SmartFocus is not automatically applied, click the "Zoom and Pan" icon, check the "Apply SmartFocus" box, and click the "Apply" button. The Zoom track appears on the timeline with blue diamonds showing where the key frames (where the zoom or pan happens) appear. As you review the placement of these, just click on one to edit it. The Clip Bin pane has an image with the zoomed area that you can drag to correct a placement

or pan out again. You can also drag the blue diamond along the timeline to make sure the Zoom and Pan happens when it should.

Some users find that the default settings work well. Others find that they do not. Because the area of focus is partly determined by where the mouse cursor is located, personal mouse usage makes a difference for its effectiveness. For this project, SmartFocus did fairly well, but I still adjusted or added about half of the zoom and pan frames.

Title Clips

Title clips are static clips that can contain text and/or a graphic. Click the more icon, then "Title Clips," and then the green plus button to "Add a Title Clip." You get a text box in which you can control the font, size, color, bold, italics, underline, drop shadow, and alignment. You can also have a solid color background or use an uploaded image.

The title clips default to a five-second duration, which can be easily adjusted on the timeline. There is no audio during the clip unless you add some. Clips can go anywhere in the timeline. I first added one at the very beginning as an actual "Title" slide. I shortened the duration to three seconds so that I could add a transition (see later) without making it take too long. At the end of this clip I added another to outline the steps I just described.

Inserted title clips create markers at that spot on the timeline. The markers can be used to create a table of contents if you produce in a format that supports them. The markers show up on a timeline track (labeled, to no one's surprise, "markers") as green diamonds. If you plan on using them and producing a table of contents, right click on one to rename it to something more meaningful in a table of contents than "Title Clip 1."

Other Media

At this point, I have a 1 minute, 43 second video but with only one example. Because my original outline called for two, I can just click the "Record the Screen" button and record a second example. At the end, I click "Save and Edit," and, after the file is saved, it is automatically transferred into the current project, pasted at the end of the timeline, and the SmartFocus is again automatically applied. This time I do not include the webcam image during recording, so the audio ends up on track 1 instead of the PIP audio track. After editing out the pauses and gaps, I cut the video down to three minutes.

You can add additional screen recording clips, full video clips, images, or audio to the timeline. Just add it to the Clip Bin and then drag and drop it

onto the timeline. The Library contains additional media. At the very end, I added the Digital Radius Intro Sequence.

Transitions

Between each media clip, you can add a transition. Scroll back to the beginning, and position the playhead at the end of the first title clip. Click "More" and then "Transitions." The timeline becomes a storyboard, with each clip or extended video as a separate screenshot. The transitions are listed in the Clip Bin pane. Double click one to see a demo of what it will look like. Click and drag to insert a transition between two clips. Bear in mind that most transitions last about three seconds. You can change the duration by right clicking on the inserted transition.

Captions

Another recent addition to Camtasia Studio is the Speech to Text transcription feature for automatically creating closed captions. Several software versions have included the option to add captions, but the transcript had to be entered or uploaded. As of Camtasia Studio version 7.1, no transcript or data entry is needed, depending on how well the automatic transcription works.

Click "More" and then "Captions." You can still paste a script or manually add captions, but click the "Speech-to-Text" button to try the automatic generation. Camtasia will pop up a screen with instructions on training the system for greater accuracy. However, in the interest of experimentation, I just skipped that part. The next pop-up box asks which tracks to use for the transcription. I checked "Audio 1" and "PIP Audio," which were the two tracks with my voice narration. (Audio 2 just had the music for the Digital Radius Intro Sequence.) Then I clicked "Continue." It takes a while for the transcription.

When it is done, you have yet another track on the timeline (Caption) and can actually see the words on the timeline. I left the original attempt on this video. Although it starts with "And snow web can import..." instead of "EndNote Web can import...," overall it did remarkably well.

Captions are supported only on Flash hosting options, so no uploading to YouTube for this one. Screencast.com, however, does support some Flash, so it would accept this screencast. I produced this using the Web default and then used FTP to transfer the files to my personal web server at Notess.com. Note that the control bar on this screencast has a small "CC" icon on the right. The closed captions are not shown by default. The viewer must click the icon to see them. The table of contents works in the same way; two icons to the left of the "CC" icon is a table of contents icon.

Clicking that will bring up the contents that were generated from the named markers.

▶ CREATE AN INSTRUCTIONAL AID SCREENCAST (NO SOUND AND DUAL PURPOSE WITH SOUND)

After years of teaching EndNote Web workshops, I decided to try an opening video to demonstrate what EndNote Web can do. I had previously used an image from Thomson (producer of End-Note Web), shown in Figure 5.14.

While I have verbally described each of these functions, I could tell that a verbal explanation failed to quickly and clearly demonstrate the three functions. Thomson has an online EndNote Web multipart screencast tutorial (Kirking and Nguyen, 2011), but it is quite extensive and does not include a quick overview. I also tried demonstrating all three functions quickly online at the beginning of the workshop, but EndNote Web can be slow, and the "quick" demo ended up taking about 10 minutes out of a 50-minute session, leaving too little time for the more in-depth hands-on exercises and explanations. That led me to design this instructional screencast, with the goal of taking less than

Project 11

Audience:	EndNote Web workshop attendees
Software:	Camtasia Studio
Hosting:	Library web server
Topic:	EndNote Web Overview

▶ Figure 5.14: Static Instructional Aid

Getting Started with EndNote Web

1 Collect

Collect references from electronic and traditional sources.

- ○ Search online database
- ○ Create a reference manually
- ○ Import references

2 Organize

Organize your references for your research topics and papers.

- ○ Create a new group
- ○ Share a group
- ○ Find duplicate references

3 Format

Create a formatted bibliography for your paper or cite references while you write.

- ○ Create a formatted bibliography
- ○ Cite While You Write™ Plug-in
- ○ Format a paper

two minutes to show all three functions. Because this would be used in a live, in-person, hands-on workshop, no sound is needed as I would provide a live narration.

Create the Click Path

In this case, I outline the examples based on the three functional categories. After searching for a good topic to use for all examples, I decide on a local interest, thermophiles. The click path outline gets quite extensive, but note how target time is included. The initial recording can be much longer, but the plan is to end up with something close to the outlined times:

1. Start in Empty Account (create a new one if needed).
2. Collect References (target: 40 seconds):
 a. Perform online search in ENW for book at MSU: "thermophiles."
 i. Add first two (target: 15 seconds).
 b. Search Web of Science for "thermophiles yellowstone," and add three to ENW (target: 15 seconds).
 c. Perform same search in Academic Search Complete (target: 10 seconds).
 i. Add first two to folder.
 ii. Show folder.
 iii. Select all and export.
 iv. Perform direct export.
3. Organize (target: 30 seconds):
 a. Go back to My References (target: 5 seconds).
 b. Select all, and add to group: New (target: 5 seconds).
 c. Title it "Thermophiles" (target: 2 seconds).
 d. Manage Groups (target: 3 seconds).
 e. Share Thermophiles Group (target: 10 seconds).
 f. Show newly shared group "Hyalite" from regular account (target: 5 seconds).
4. Format (target: 45 seconds):
 a. Open Word.
 b. Click "EndNote Web" tab and log in (target: 5 seconds).
 c. Change style to AAGP (target: 5 seconds).
 d. Add page break at bottom and "Bibliography" heading (target: 5 seconds).
 e. Scroll up to text and search reference (target: 5 seconds).
 f. Add one (target: 5 seconds).
 g. Scroll down and show bibliography (target: 5 seconds).

 h. Add another in-text, with two citations (target: 10 seconds).

 i. Scroll down and show bibliography (target: 5 seconds).

Record and Edit

Because this is intended to be a silent screencast, the original recording can be much longer as it will be cut down during editing. Any time that something does not work quite right, just keep going and record it again. Before recording two separate programs (web browser and Microsoft Word), check the window dimensions and positions. I aligned the Word windows directly behind the browser. The EndNote Web add-in for Word pop-up windows did not fit within the recording area, so I just resized them during recording.

Running through the whole outline resulted in a long original recording time (10 minutes, 50 seconds). Moving to the editing interface, start by cutting dead space. Use the timeline zoom tool to more precisely select the parts of the timeline to cut. The first pass at cutting pruned the first section down to just 54 seconds, just over my target of 40 seconds.

Before moving on to the next section, run the first part to evaluate the overall flow. A danger with cutting is that the result can move too fast with no time for the viewer to recognize what happened. In this case, most of it flowed well, but at the end it cut too quickly to the Web of Science example. To add a two-second pause, move the playhead to that last moment when the desired screen is displayed, and then extend the frame by pressing the "E" key (or go under the Edit menu and choose "Extend frame"). Enter the duration for the extended frame in seconds. I also extended the last frame of the second example by 1.5 seconds.

Editing the second part (Organize) consisted of again cutting some sections and extending others. Complicating that section's editing was discovering that I had missed a section in the initial recording. I had paused while working on one section and failed to un-pause soon enough. To add the missing section, I went to the missing screen and started up Camtasia Recorder again (making sure to set the recording dimensions exactly the same as the original video). I recorded a two-second video, saved it, added it to the Clip Bin, and then inserted it at the correct point.

The final section, Formatting, had the most time to cut because of several false starts. After all the removals, the section still seemed a little long, so I cut the log-in section from the outline because it was less important—I cover that later in the workshop and it was not important for the instructional point, so it made sense to delete it. The overall screencast length at this point has been reduced from almost 11 minutes to less than 2.5. Editing takes time but can create a screencast that delivers the instructional point much more quickly.

Add Callouts

After viewing the entire video, it seemed to have an appropriate duration and moved from point to point at a good pace for my live accompanying commentary. The real test would be how it works in the classroom, and, because I had some time before the next workshop, I decided to add some callouts to help emphasize each of the three main functions and what was happening on the screen. I could use Title Clips to help separate the three functions, but those take more overall time, whereas callouts can just be placed in a less important part of the page. I used a different background color for each of the three functions. I also found another few seconds to cut in the middle section. The last callouts include the EndNote Web introductory image (using a Load Image callout) and a final text box ("EndNote Web: Manage Your Citations") in a fourth color so that when the video finishes running the text will remain on the screen.

Produce and Host

Because I plan to host this screencast on a library web server, I produced the project using Camtasia Studio's Custom Settings. Hosting on the library server makes sense for this in-class tutorial because I typically teach this workshop in the library, and it should deliver faster and more reliably from a local server. The Custom Settings production choice has many more options than the quicker to produce preset production setting choices. If I use several specialized options that I plan to include in future projects, I can even save the settings as a preset to make future productions easier.

In this case, I chose Custom Settings/Flash output with the ExpressShow control, original dimensions, and no Table of Contents. On the Flash Controls options, I allowed resizing, a full-screen option, pause as start (so the viewer controls when it starts), and added an About box and Start screen. The About box can contain text and an image, although I just used the text functions. The About box is displayed if the user clicks on the small "i" icon on the controller bar. The title was set as "EndNote Web Quick Demo" and the about text as "An MSU Library Screencast: EndNote Web features by Greg R. Notess." The Start screen options include a text description, an icon, a thumbnail, and background color. The icon setting is an opportunity to load a logo on the start page. The thumbnail is a smaller image displayed in the center before the video starts. The default thumbnail setting is First Frame, but another image can be loaded instead.

The next settings screen has even more options, including Video Info, Reporting, Watermark, and HTML (see Figure 5.15). The Video Info options

▶ Figure 5.15: Video Options Production Screen

let creators add a variety of fields of metadata that will be added as Dublin Core tags in the header of the produced HTML page and iTunes tags. Reporting allows connections with a SCORM-enabled e-learning system. SCORM (Sharable Content Object Reference Model) is a standard for transfer data such as quiz results or viewership, but I find that few libraries have such an e-learning system, and those that do (primarily academics using Blackboard, Moodle, and Desire2Learn) rarely have the technical support to make SCORM connections easy. The Watermark lets you put a faint image on the entire video and is usually used for branding.

On this screen, the only option I use is the last one, for creating a webpage with the video already embedded. As mentioned in the production of Project 9, the Web preset, and all the versions of Camtasia before version 7, create HTML with the title tag of "Created by Camtasia Studio" followed by the version number. So for years I have just gone into the produced HTML and changed the title element. With Camtasia 7, TechSmith added an HTML Options button (although only in the production Custom Settings). The

only option available is for setting the title, which I change to "EndNote Web Quick Demo: An MSU Library Tutorial."

The next Custom Settings screen lets me choose the location for the output files, choose whether or not to organize the multiple produced files into a subfolder (which I always do to make transfer easier and to make sure I keep all the files together), and use the Post Production Options. The lower part of the screen shows all the files that will be produced and the folder path. The Post Production Options include choices to Show Production Results (displays a summary of the file location, output files created, and the settings used for production), Play Video After Production (before upload), and Upload Video by FTP. Choosing the Play Video setting means you will be able to see the produced video as soon as it is done, which is a great way to check that it looks and sounds like you wish. If it does not, you can easily go back and change a few of the production settings. I typically first produce the project on my own computer and then transfer the files to the server so that I can double-check everything before uploading. Click "Finish" to start the project rending.

Because this screencast is for my own use during workshops and not publicly linked, I will upload it to my personal web space on the library server. To keep the URL short, I use a short directory name ("/enw/" in this case) and change the HTML file name to "index.html."

Edit for Multiple Uses

Editing software makes it easy to reuse parts of one screencast or the whole thing for another project. After working on this project for a visual within a live instruction session, and then especially after adding the callouts, it just made sense to consider also using it or part of it for an asynchronous online instruction purpose. I had been planning to create this for months, and with all the editing it would take longer to create than many others. So, I decided to create a second screencast with audio for a target audience of potential asynchronous students.

Add a Postrecording Audio Track

First, make sure to save the Camtasia project file right after producing the finished, no-audio instructional aid screencast. Then, for the new project, go back to File and Save Project As to give the new project a different name so that each can be edited separately later.

Adding an audio track after recording is easy to do in Camtasia Studio, but it can be difficult to time appropriately. An audio track can be split and a frame extended to make the video slow down to match the narration or more video could be cut, so rehearse the audio without recording first.

When ready to record, click the "More" icon below the Clip Bin area and then "Voice Narration." The playhead should be at the beginning of the timeline. The Voice Narration window lets you put the audio on one of three audio tracks and mute the speakers during recording (a good idea if you have e-mail open or might get other computer noise interruptions). The Input Level meter lets you know the microphone is working, and the Audio Setup Wizard is for choosing and testing microphone input. The Recording Duration section offers several options, including a box to check to auto-extend the last video frame in case the video ends before you finish talking.

Try the "Until I Manually Stop or End of Selection on Timeline" and "Auto-Extend" in case you talk longer than the video. Click "Stop Recording" when finished and Camtasia prompts you to save the audio file.

Then back to editing. Click the "Audio" tab and "Enable Noise Removal" to get rid of the background white noise. Listen a few times to see if the timing works, if there are noises to be replaced with silence, or if some parts need to be rerecorded. For this version, I adjusted one callout's timing and the wording in the final callout, and I reduced the editing dimensions to fit within a two-column LibGuide layout.

Producing this with Custom Production Settings enables exclusion of the table of contents, tweaking the start screen, adding content to the About box, and retaining the settings from the last project. You can upload the files to a web server. For directions on how to include this in a LibGuide, blog, or other similar site, see the *Embed Camtasia Video in LibGuides* document on the companion website (http://www.alatechsource.org/techset/).

▶ ADD A QUIZ AND CAPTIVATE OVERVIEW

Adobe's Captivate is often compared to Camtasia Studio as full-featured screencasting software; however, it is primarily designed for a slightly different purpose. It is sold as part of a larger (and more expensive) e-learning suite that can be used to create online course and related material. Early versions of Captivate focused on creating software demos. As a result, the underlying emphasis is less on video than on a frame-by-frame approach somewhat similar to Wink. As of version 4, Captivate can create full-motion screencasts, but the structure is different. Some people find this approach too complex and time-consuming, while others prefer this approach. Librarians are split as well. Ones with whom I have talked who have access to Captivate have either found it too confusing and

Project 12

Audience:	Public
Software:	Captivate
Hosting:	Personal website and YouTube
Topic:	E-books at HathiTrust

difficult to learn or invested time into learning it and then tend to prefer it. It potentially can create smaller files, because, in the automatic recording mode, it just takes a snapshot of each screen change along with mouse and button clicks, but in practice I find most Captivate screencasts are about the same size or larger than a file produced with a full-motion video. Rather than explore all the possibilities of this complex program, this project shows you how to create a screencast with audio.

Rather than my usual click path outline, I am using a storyboard with a script for this recording (see it on the companion website at http://www .alatechsource.org/techset/). However, this covers only the recording process and not the editing process later. For that, I plan to show a callout (which Captivate calls a "Text Caption") and a Flash quiz.

Download Captivate

Like Camtasia Studio, Adobe offers a 30-day free trial of Captivate. Given the learning curve, wait until you have some time to explore the software. Fortunately, it is the full-featured version. Go to http://snipr.com/dlcaptivate and create a free Adobe account (or log in if you have an existing one) so you can download the trial.

After the software is downloaded, start the installation by accepting the license agreement and then clicking "Install this product as a trial." You must select a language (two versions of English are available, so choose either International or North America) before you can click "Next." Choose the installation location, or just click "Install." Once it finishes, click the "Adobe Captivate" button to start up the program. It again prompts for a serial number, but just choose "Start Trial" (and note the countdown message for the number of days remaining for the trial). Captivate again asks you to enter your Adobe ID (the one you used to get the download file). On Windows, Captivate needs to be run with Administrator privileges to be able to capture the screen.

Record with Captivate

Once Captivate loads, it pops up the start-up screen with choices for creating a new Software Simulation, Blank Project, From Microsoft PowerPoint, Image Slideshow, Project Template, From Template, and Aggregator Project, as shown in Figure 5.16. For screencast recording, choose "Software Simulation" or from the main editing screen use "File" and "Record New Project" (or just "Control-R").

You can use the top part of the next screen to select the recording area. Use "Application" to lock to a particular program or "Screen Area" to select

▶ Figure 5.16: Captivate Start-Up Screen

just a portion (like the browser window used in this example). In the lower part of the window, choose "Full Motion" as the recording type instead of Automatic, which is the frame-by-frame approach. (Although you can use that to make a screencast, it is a different approach than used elsewhere in this book, so I am sticking with the more standard screencasting approach.) Also be sure to select the correct microphone in the Audio dropdown menu and then test the level using the Auto Calibrate function.

Once you click "OK," you get a three-second countdown before the recording begins. Press the "End" key on the keyboard to stop the recording. Captivate pops up a window while it is Creating Slides and Objects, and you are taken to the editing window.

Edit in Captivate

On the left side of the editing window is a single item in the Filmstrip tray, which is the recording that was just made (see Figure 5.17). The timeline is in the bottom center of the editing window. The leftmost column contains many icons for adding special effects and features, and the right side is a

▶ Figure 5.17: Captivate's Editing Window

Properties pane that gives the feature's options. Click the double arrowhead icon in the upper right of the Properties pane to minimize it.

To add a callout or, as Captivate labels it, a Text Caption, click on the top feature icon on the left, which looks like a speech bubble with a T in it. A box appears on the screen, and you type your text directly into the box. Use the Properties pane to change the color of the callout and the direction of the speech bubble. You can also adjust the duration of the callout and have it fade in and out.

To adjust the audio, click the "Audio" tab at the top and then "Edit" and "Slide." Be sure you have chosen the single slide in the Filmstrip pane for your recording. You can select a portion of the audio to then cut (scissors icon), copy (two squares), delete (trash can icon), or replace with silence (last icon). Near the bottom of the audio editing window is an Adjust Volume button for raising or lowering the volume. The Normalize option works well and is designed to automatically select the best volume. There is also a Dynamics option that reduces the loud sections, and you can add closed captioning.

To add a quiz at the end of this clip, go to the Quiz option in the menu bar and choose "Question Slide." You can then select from several types of questions and specify whether the question is to be graded or is just a survey. This function adds a new slide in the Filmstrip pane for each question and one for the results.

Produce from Captivate

When you are finished editing, look to the top bar for the Preview and Publish icons, or click on "File" for both functions. Preview can be used to preview individual slides or to preview a finished project in a web browser. Captivate generates the project and then opens the default browser and starts it playing.

When it is satisfactory, click "Publish," give the project a title, and select "Publish to Folder." These choices are under the Flash option on the left, which is the default option. Under "Output Options," choose "Export to HTML." On the right, click "Preferences" to see many more choices, such as including the mouse, enabling accessibility, and setting frames per second. Select the Quiz settings on the left so you can enable reporting for the quiz via SCORM, Adobe Connect, Acrobat.com, e-mail, and other choices. You can also get reports as a score or percentage and can choose what data to have included in the report.

Under Project are settings for Start and End, such as enabling Auto Play or not, using a preloader (the video that plays while the main one is loading), and specifying what to do at the end: stop the video, loop it, open a URL, open another project, or even send an e-mail to a specific address.

Click "OK" after selecting all the choices you want and then click "Publish." When it is complete, Captivate asks if you wish to view the output. Select "Yes" to view it in a browser. The final output for the project contains three files: a JavaScript, the Flash video, and the HTML file. Just upload these to a website and link to them. Captivate also has a YouTube button for quick publishing to YouTube. Click it when done and enter your YouTube username and password. You are then prompted for YouTube information, such as a title, description, tags, and whether you want it private or public. Although Captivate will publish the project to YouTube, the Flash quiz will not be interactive and just scrolls by.

►6

MARKETING

- ► **Publicize**
- ► **Choose Hosting Options with RSS Feeds**
- ► **Integrate RSS Feeds into Websites, Twitter, and Facebook**
- ► **Market with Traditional Print Media**

Because screencasts can be used for a wide variety of functions, marketing needs will be varied as well. Little marketing is needed for the screencast audience of one (Jacobsen, 2011)—just an e-mail or other mechanism to share the URL. Screencasts for a small group such as a class or workshop can just be shared in the instructional setting. Marketing is most needed for screencasts intended for a broader audience: the general public or larger groups of your library users.

The nature of the instructional content within library tutorials in general rarely attracts large numbers of viewers. The challenge is to make them available at the point of need and to let potential viewers know of their availability so that when such instruction is desired, it is easy to find and view. As Betty (2008: 310) concludes, "Creating the tutorials is not enough, as more work needs to be done in publicizing their availability and content. As evidenced by the lower usage of some tutorials, students may not be aware of the services covered in the tutorials. Therefore, marketing should not focus solely on the tutorials, but should alert students to the availability of general and specialized library services as well."

►PUBLICIZE

Because screencasts are born digital and live online, marketing them may also best be done online. Given the current interconnectivity of the web these days, online marketing can be synchronized in a variety of social media sites and more static webpages. It is relatively easy to have announcements

Tip: Language for Patrons

The term "screencast" is likely to resonate less with most library users than "tutorial." Patrons in general care less about the tutorial technology than the relevance of the instructional content to their work, so consider identifying the links as "tutorials."

from a blog post also appear in Twitter and on Facebook. Other webpages can take and embed a feed of links to new screencasts.

Links from a library homepage are a great starting point. Once at least a couple screencasts are created and live, add a link to them to the homepage. Also consider adding a link to, or embedding the screencast on the page that goes to, the resource covered. If you create PubMed screencasts, a link to those tutorials should be clearly identified on the pages that also link to PubMed.

► CHOOSE HOSTING OPTIONS WITH RSS FEEDS

Several online video hosting sites have RSS feeds that, based on the account log-in, can automatically add to the feed any newly uploaded videos. Do you want to publish all of your screencasts to YouTube and then just embed them on the library site? A hosting approach like this makes it easy to also post a list of recently published screencasts on the site as well; take the YouTube RSS feed for the channel and then, using a widget, place it on the library site—and any other related site that may be appropriate (the university or larger organization's site, nearby schools, city government, nearby libraries, etc.).

YouTube is not the only choice for using RSS feeds for marketing. Here is a short list of video and screencast hosting sites that have RSS feeds available based on a user account (most have other Web 2.0-style social options like comments, ratings, and responses as well):

- ► YouTube
- ► Screencast.com
- ► Screenr
- ► Vimeo
- ► Viddler

In addition, if you consistently post either news about new screencasts or the embedded screencasts themselves to a blog, most blogs have RSS feeds that could be used for the online marketing as well.

► INTEGRATE RSS FEEDS INTO WEBSITES, TWITTER, AND FACEBOOK

There are many ways to use social media to update a library's website. WordPress users can add an Embed RSS plug-in. Other tools and widget

creators are widely available for free on the web, such as RSSinclude.com, Google's AJAX Feed API (at http://www.google.com/uds/solutions/wizards/dynamicfeed.html), and RSS2HTML.com. Go to any of these sites, being sure that you have the URL for the RSS feed, and then walk through the steps to create code that can be placed on a webpage or in a blog. The RSS widget will display new items without requiring any additional work. This achieves instant online marketing of a new screencast within minutes of when it is published. However, it only reaches an audience of people who view the webpage.

Then expand your marketing reach to Twitter and Facebook. If you don't already have these accounts, set them up. Then set up an account at Twitterfeed.com. This free tool makes it easy to automatically post about new screencasts. Just enter the RSS feed URL into Twitterfeed and then choose which services to activate—currently Twitter, Facebook, StatusNet, and Hellotxt are available. You will need to provide your authentication to Twitterfeed, and from within Twitter or Facebook you may also have to allow Twitterfeed access to your account.

In all cases, the title in the RSS feed is typically used as the title in the link on the webpage, on Facebook, or at Twitter. Title your screencasts with this in mind if you will be using this market approach. For example, a title of "Lesson 2" or "Next Steps" will not be as informative as one that includes the overall tutorial title, such as "Library Tutorial: Lesson 2" or "Finding Articles: Next Steps."

▶ MARKET WITH TRADITIONAL PRINT MEDIA

Online marketing, even when it is automated, will not reach all potential viewers. Word of mouth and print campaigns may be even more effective. At Regis University, the library found that an announcement within the news section of the library's website was most effective at capturing the attention of faculty and administrators, and effective student marketing included an article in a student newsletter and promotional bookmarks (Betty, 2008).

One way to tie the print marketing directly to the screencasts is through the use of QR Codes. Wert (2011), for example, used a QR Code that led to a screencast of one of his lectures. QR Codes are like black bar codes that contain embedded information. QR Code readers are freely available to smartphone and tablet users (iOS, Android, and others). Thus, a user with a smartphone and a QR Code reader app can just snap a picture of the QR Code on a bookmark, newsletter, or other publication, and the screencast will play on the mobile device. If you want to use this approach, be sure that your hosting service supports videos on mobile devices. Because Apple's iOS (used on iPhones, iPads, and iPods) does not support Flash, an alternative

delivery option is needed. Fortunately, both YouTube and Screencast.com have such alternatives, but be sure to check that your screencasts work; success will depend in part on how you upload the video to the service. For more on how to create QR Codes for your library, see Joe Murphy's *Location-Aware Services and QR Codes for Libraries* (THE TECH SET #13).

▶7

BEST PRACTICES

> ▶ **Record with Library Users in Mind**
> ▶ **Review Your Planning Process**
> ▶ **Ensure Audio Quality**

With the wide range of screencasting software, both free and fee, not to mention the ease of using web-based recorders, it has become simple to create a screencast. However, screencasts work best as library instructional aids when they are well-constructed, carefully planned, brief, and clear about the main instructional points.

Based on the many screencasts I have viewed and the reactions of students in my workshops, I have developed a variety of best practices. Like most guidelines for what is (in many ways) an artistic endeavor, there are times and reasons to break the rules. These recording tips, planning suggestions, and audio quality tips are a starting point for best practices.

▶RECORD WITH LIBRARY USERS IN MIND

Aim for a succinct screencast. Or, to riff on the usual KISS acronym, "Keep It Short, Screencaster!" After all, most of what libraries like to teach is not top on the time priority list of our users. Librarians in general (and I am as guilty of this as the next) tend to prefer a comprehensive coverage of a topic. We like to provide instructions for every possible exception and teach alternatives rather than just a single way to do something.

With screencasts, we are ceding control to our viewers. They choose whether or not to start watching and continue watching, and they can set their own volume. With typical video controls below a screencast, the more interested viewer can rewind and replay, and the impatient one can skip ahead. So, keeping it short increases the chances that a viewer will watch the entire video.

Keeping it short has several advantages for the production process as well. If there is a problem or error, it is quicker to rerecord the entire short

screencast than to edit just the error. When an interface or function in the screencast is changed or updated, a short screencast will also be quicker to update to reflect the new design, function, or feature. And, if screencasts are too time-consuming to produce, you will not likely create many.

Video Tips

In a similar vein, keep the screenshot small. Rather than showing the entire computer screen, show only the part that includes the content being taught. Especially with the rise of netbooks, mobile phones, handhelds, and tablet computers, smaller video shots are more likely to be viewable by a wider range of computing equipment. Plus, smaller dimension videos will have smaller file sizes, be quicker to load, stream faster, and more easily fit on a webpage as one part of a larger project.

How small a window should be recorded? Enough to see clearly the examples without losing context. When rehearsing, try for a smaller browser window, and then run through the examples to see if it can be made smaller without losing the instructional point. Run a short test, and be sure not to move the window around on the desktop. Also, close any other windows underneath that are not needed for the screencast. If any pop-up windows are generated, those can be moved so that they appear within the recording frame, and then just switch to them at the appropriate moment rather than generating a new pop-up that may appear outside the recording window.

In general, minimize visual clutter. Avoid or close browser bars and images that identify the browser being used (unless that is part of what is being shown or taught). Size the recording window so that only the browser content is displayed, and you may be able to avoid alienating viewers who dislike your browser or operating system choice. When screencasters record the entire screen, I find that I get distracted looking at the toolbars, status bars, and notification area to see what other programs are running. Exclude that kind of distraction, and let the viewer focus on what is being taught.

It is also wise to shut down any other unneeded programs, especially e-mail, IM, and chat applications. Otherwise, you may get incoming e-mail alerts, chat pop-ups, or Skype calls right in the middle of recording. Want to avoid getting a phone call? Turn the phone off, take it off the hook, or forward the calls.

If you intend to explain how to open something from the desktop, before recording change the desktop wallpaper to a solid color. Put unnecessary icons into a folder that you hide elsewhere. If you do need to record the whole screen (to demonstrate software installation, for example), you can still keep the dimensions smaller by changing the screen resolution to 640 × 480 or 800 × 600.

While recording, remember that all cursor actions and clicks are being recorded. Try to avoid extraneous cursor movement and clicks. If you are used to showing an in-person user how to do something on a computer, you may be used to pointing with the cursor and clicking for emphasis. After recording a few screencast test runs, see if the same behavior highlights the instructional point or distracts from it.

▶ REVIEW YOUR PLANNING PROCESS

Although Chapter 3 covers planning in more depth, I want to mention several planning best practices here that will help make the recording process go easier. After creating the outline and click path, remind yourself of the main instructional point or points (and there should not be too many) before you start the recording. Ask yourself if your plan will demonstrate those points clearly and easily. If it is too long and complex, consider paring down the number of points to be made and excluding extraneous material.

If you use a script, avoid sounding like you are reading it. If using closed captions or full text on the screen, try to say the same thing with different words. Use a user-controlled closed caption option if needed for hearing impaired viewers rather than always having the exact transcript of the words on the screen.

Review your examples. Certainly the examples should support the instructional point(s). But beware of distracting elements. For example, if you plan to do a search that results in three citations, and you plan to use the first one to demonstrate how to find the full text and import it into a citation management tool, do not neglect to look at the other citations. Does one have an unusual title? Does it have an obvious error? Will both fail to work the way the first one does if a viewer tries it?

In addition, is it an example that a student can use to practice the process being taught? If so, guess the likelihood of future changes to that search. Will more records be added soon that will not work as well? Will it change the effectiveness?

Although the point of planning and rehearsing is to avoid all errors, anticipate that some errors will still occur. If you're using a recorder with no editing capability, just stop and rerecord. If you have editing capabilities, add pauses to the recording with no speech or cursor motion. This makes it easier in the editing stage to identify sections for deletion or changes. It also helps you to get into the habit of having pauses. In the event of a distraction, like a phone ringing or fumbled speech, just stop talking for a few seconds, and then start again at the beginning of the previous sentence or point you were planning on making. This can make it easy to edit out the error.

▶ENSURE AUDIO QUALITY

It is easy to get too caught up in creating the perfect audio experience. Just remember that most of our users are not likely to expect fully professional audio sound for a quick screencast. The YouTube generation is used to hearing all types of voices and accepts lesser sound quality more readily. The key to quality is to make the audio sound conversational rather than as if being read from a script. As Steeleworthy (2009) puts it, "Most screencasts are small 1–3 minute wayfinding guides, so it won't be the end of the world if you mumble your way through 'open access electronic databases' on every take when laying down your audio."

Again, it is good practice to incorporate pauses. Especially at the end of a recording, be careful not to stop the recording too soon. Instead, leave several seconds of silence at the end. This avoids cutting off the last word or the last consonant in the word. If it is too long, it is easy to delete the last few seconds. It is much harder to fix a final word.

To adjust the volume, test the level on your speakers or headset first by listening to a mainstream news site that has audio or video (YouTube video and popular celebrity sites tend to have some unusual volume levels). Adjust the volume while listening so that it is a comfortable level, and then do not change the volume control (on the speaker, headset, or computer) after that. Then try a short recording to see if your voice is too loud, too soft, or, as Goldilocks might say, "just right."

At the beginning of a recording, learn the oddities of your microphone. Some mics wait to turn on until they pick up sound. If you have one like that, say something, then pause for a few seconds, and then begin to record. Again, you can delete the first sound, which might be an initial pop or buzz, and you will avoid cutting off the first word.

Some recorders provide additional sounds. For example, Camtasia Studio can add mouse click sounds and keyboard sounds, which emphasize when you click with the mouse or type on the keyboard. General opinion is that while the mouse sounds can be helpful, the added keyboard sounds are terrible. They sound like a typewriter. Plus, for us heavy typers, the mic may well pick up actual keyboard sounds when we type.

Music-Only Audio

I have come across several screencasts that take a rather radically different approach to the audio track. Instead of using spoken dialog to describe the process and instruct the viewer, the only audio content is music. Two examples come from several years ago but continue to remain online. I have

played both screencasts to many workshop groups and get an interesting reaction.

First, consider the CustomizeGoogle screencast at http://www.customize google.com/movies/intro-flash.html, which shows how to install and use this Firefox plug-in. Bear in mind that this is from 2006, and, because Customize-Google has not been updated since 2007, the content is no longer accurate (although other plug-ins exist and continue to be developed for the same functions, like OptimizeGoogle). The main point is that the screencast itself is well-designed. If follows many of the practices discussed earlier, such as having a clear visual focus on just the parts of the screen that are needed. Note how, at its opening, the computer desktop has a solid background and shows only one icon—for Firefox—with no distracting operating system toolbars or extraneous links. It uses a few callouts to emphasize what action is being taken rather than an audio track with someone explaining the process. Instead, the audio is a simple, lively music-only track.

My initial experience with this screencast was positive. It was shorter than two minutes, and the music helped hold my interest while the video demonstrated the installation process and ways to set options. The music starts after a few seconds rather than right at the beginning. Video actions on the screen change at least every few sections, so it does not leave the viewer waiting for more. The callouts display on the screen long enough so that there is time to read them.

When showing this screencast in workshops, audience reaction was mixed. Typically, a majority (of librarians) either liked the background music or at least did not find that it interfered with the instructional intent. However, a minority complained that it was too distracting. Given mixed audience reactions, this is an important reason why giving the viewer access to controls like the mute and volume buttons is important.

When comparing the effectiveness of this screencast to several vendor-produced database tutorials (e.g., a LexisNexis one from that same time period at http://lexisnexis.com/tutorial/global/globaltutorial_frameset.asp ?locale=en_US&lbu=US&adaptation=Academic&sPage=overview), I found the CustomizeGoogle one to be much more engaging and a quicker learning experience. The LexisNexis tutorials have no sound of any type (perhaps someone assumes they would be viewed in a library), and, to see each instructional point, the viewer must click a next button. Despite my personal interest in the LexisNexis interface being shown (which was greater than my interest in CustomizeGoogle at that point), I found that I quickly grew impatient with the tutorials. For one thing, the controls are at the top of the tutorial rather than at the bottom as on most online video players. Even though I could control the pace, I found it slow and confusing. The Selecting

Sources section of the tutorial tries to include user interaction with a "You try it" option, but after the user clicks a particular button, no additional interactivity is provided. I would rather have either an audio commentary or at least the entertainment of the CustomizeGoogle-style music track.

Another example of a music-only screencast comes from CrossLoop. Again, this is an older screencast, from 2008, but for now at least it is still available at http://www.crossloop.com/crossloopmarketplace/homepage video.html. Like the CustomizeGoogle demo, it is less than two minutes, uses textual callouts to describe what the video shows, and it has a music-only audio track. Audience reaction to it, however, is pretty extreme.

When viewing this screencast, most audiences uniformly hate the music track and say that they would stop watching the video. There is no mute button, although there is at least a volume control so that the track can be silenced. What makes this music track so annoying compared to the other example? It is a simpler, slower track, but the main problem is that it is on a short loop of about 10 seconds. Looping the track makes it repeat over and over until the end of the video. It starts immediately and ends part way through the loop. The CustomizeGoogle music is not timed to end with the video, but it does at least fade out, which reinforces that it is ending.

►8

METRICS

- ► Request Feedback
- ► Employ Usage Statistics
- ► Use Comments and Ratings

At the 2011 ACRL conference, a team from the University of Michigan reported that "The results of this study indicate that screencasts facilitate student learning" (Oehrli et al., 2011). How can we evaluate our own screencasts to see if we can obtain similar results? Because screencasts are in such a wide variety of ways, it depends on what is appropriate to measure.

Screencasts designed for individuals (single reference interactions, sharing with a tech support person) are expected to have low usage statistics, and even a single viewing can be a sign of success. On the other hand, it is even easier to just ask the intended audience if the screencast helped or not. The success of screencasts designed for class-sized audiences, general library users, and other large groups can be gauged in several ways.

►REQUEST FEEDBACK

As with any kind of instruction, feedback can be gathered with forms, online surveys, and a general discussion. The intended audience for the screencast generally won't be gathered together in a room, so online feedback may be easier. Again, it depends on the intended audience.

For classes that will be viewing screencasts as part of an assignment, the best kind of feedback for measuring the success of the screencasts' instructional goals is to give the students a pretest for evaluating their skill levels and then a posttest after they have viewed the screencasts, as was done in the Oehrli et al. (2011) study. However, in many classroom settings, this may be difficult, and it is time-consuming to develop accurate instruments for measuring the skills. A simpler, less time-intensive approach is to hand out a simple paper feedback form at the end of the class asking the students to rate the

instructional effectiveness of the screencasts as well as any other instructional methods used.

For those screencasts intended for the public or a more general audience, you could add a link to a feedback form (or online survey) and place the link on the same page that has the embedded video (or that links to the video). Return rates on such surveys tend to be low. Another approach is to embed a feedback option within the video itself. The quiz capabilities in Camtasia Studio and Adobe Captivate can be used to gather feedback. A quiz can even be inserted in the middle to force feedback before the video continues (although the viewer could choose to just leave as well).

▶ EMPLOY USAGE STATISTICS

Simple metrics are available at most hosting locations and at least give a count for the number of times that a webpage containing the screencast is requested. For screencasts hosted on a personal or organizational website, local website analytics usually give this information. How helpful are such metrics? One central difficulty is that most systems record when the page containing the screencast is loaded. This does not necessarily mean that the video has been viewed or viewed in its entirety. At YouTube, for example, because the videos start playing automatically when a page is visited, each time someone goes to that page counts as a "view." As someone who rarely watches more than the first few seconds of most YouTube videos, I find that count to be less interesting than finding out how many people have watched the entire video (information that is not available).

Also bear in mind that every time you watch the video to make sure it works correctly can also be counted as a view. Screencast-O-Matic records every time the screencast is loaded and starts playing, including even by the logged-in creator. In other words, after I record a screencast, every time I view it to check on how well it worked is counted as a view.

Website analytics packages like Google Analytics provide detailed usage statistics for pages on the site, including the previous page and the next page the viewers visit (see Figure 8.1). However, just because a browser loads a page with an embedded screencast does not mean that the person actually viewed all or even part of the screencast. Some libraries have integrated Google Analytics not only into their website pages that contain screencasts but have explored using code within the Flash production to track when a specified action is completed (Betty, 2009).

For Flash videos where you can set an end action, you could produce the video so that it goes to a special page, which perhaps says something like "thanks for watching" and has links to the resources being demonstrated. As

▶ Figure 8.1: Google Analytics Usage Statistics

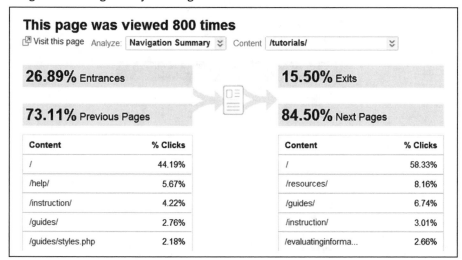

long as that page is not linked from anywhere else on the site (and it is set to not be found by search engines via a robots.txt file or a noindex header), then just check the hit statistics for that page to determine how many times the video was run through to the end. This is an easy way to check how many times the video ran all the way to the end, but it may inconvenience viewers who might want to replay a portion of the video instead of being taken to another page. To replay, they will need to use a browser back button to see the video again.

▶ USE COMMENTS AND RATINGS

Social video sites typically have user comments and ratings features, and they can be useful to get a sense of what some of your audience thinks about the video. YouTube has Like and Dislike buttons (thumbs up and thumbs down). Bear in mind, though, that only a very small portion of your audience will use these buttons. Checking at YouTube for a few videos, I found one with over 2,000 views but only six comments. Another video that purportedly has been viewed more than 65,000 times has a grand total of 39 Like and 26 Dislike ratings. Most library screencasts have far fewer views, so do not be surprised if you end up with no comments or ratings.

Figure 8.2 shows an example of video hosting metrics. In this case, the statistics are for a Bond University screencast hosted at Vimeo. The statistics show a good viewership of over 200. Even with that many views, there is not yet a single comment or "like." This does not mean that the screencast failed

▶ Figure 8.2: Video Hosting Metrics

1 Related collection

⬚ **Bond University Library**

Statistics			
Date	Plays	Likes	Comments
Nov 14th	1	0	0
Nov 13th	2	0	0
Nov 12th	0	0	0
Nov 11th	1	0	0
Nov 10th	0	0	0
Nov 9th	2	0	0
Nov 8th	1	0	0
Totals	**223**	**0**	**0**

❮ Prev week

to teach users how to, in this case, use the library's Summon discovery tool. It just means that none of the 200+ viewers took the time to comment or "like" the screencast. If the majority of viewers were indeed wanting to learn from the screencast, it makes sense that few make it a favorite or even comment on it. Ultimately, some of the best feedback is anecdotal, when you hear from people who have viewed the screencast and then used the information successfully.

9

DEVELOPING TRENDS

▶ **Anticipate Delivery Changes**

▶ **Explore Tablet and Handheld Options**

▶ **Expect Screencast Ubiquity**

Screencasting is becoming more and more common in a variety of venues, including libraries, schools, software companies, and other technology-oriented industries. It appears to have been an active growth industry. New screencast creation software and hosting platforms were being developed and older ones expanded features and options. However, in 2010 and 2011, several of the free services (ScreenToaster, ScreenJelly) closed down. At the same time, Screencast-O-Matic expanded services and introduced a very inexpensive (although it went up 33 percent from $9 to $12 per year!) option with editing capabilities. Commercial tools like Camtasia Studio and Captivate continue to launch new, updated editions, and both expanded from Windows-only to offering Mac versions as well. So, the industry appears to be maturing. However, the balkanization of delivery technologies may cause some instability, or at least make it more difficult for everyone to view the screencasts.

▶ANTICIPATE DELIVERY CHANGES

With the expansion of browsers, plug-ins, and computing platforms (especially the move toward tablet and handheld computing and the rise in prominence of Apple-created products running iOS), the delivery of video content on the Internet is changing. For the past many years (in Internet time), we could count on the vast majority of our users connecting to the Internet with a computer, using a standard web browser (most likely Internet Explorer or Firefox), and having the standard Flash plug-in installed. Many measures showed that more than 95 percent of users had Flash installed, with Adobe claiming 99 percent penetration in March 2011 (see http://www.adobe

.com/products/player_census/flashplayer/). This was driven in part by the rise in popularity of video sharing sites like YouTube. To find out if your audience had Flash, you just had to ask if people could view a YouTube video to know whether or not they could see your Flash-delivered screencasts.

Unfortunately, popularity can breed contempt (or, as others like Steve Jobs might say, Flash has performance, reliability, and security issues, and they want alternative technologies). As of this writing, iPads and other iOS devices do not have Flash. With this demographic growing, the percentage of users with Flash available on their device could decline in the near future. Newer technologies like HTML5 and Adobe AIR play video in different ways and may begin replacing Flash as the video player of choice.

This kind of technological change may lead to a period of uncertainty and competing standards for sharing video. If competition gets too divisive, it may be difficult to create a single video that will play on all platforms. I certainly hope this will not happen. Hosting sites like YouTube and Screencast.com are already starting to find ways of serving videos in Flash when it is available and via other means for iOS devices.

▶ EXPLORE TABLET AND HANDHELD OPTIONS

On the content creation side, the growing use of tablet and handheld computing raises issues of recording for those platforms. Want to show someone how an Android tablet works with your library catalog? You will need a screencast recorder on that device. Unfortunately, they are few and far between at this early stage. Neither Android nor iOS supports Java, so web-based recorders like Screenr and Screencast-O-Matic will not work. Nor are there apps available at this time from TechSmith or Adobe. However, some screencasting apps for tablet and handheld devices are starting to appear in 2011. I expect this market will eventually grow with new apps from established players like TechSmith and Adobe.

For Android, one early example was the app ShootMe; however, it requires a rooted Android device. Rooting is creating administrative access to the Android device that allows more customization of the device; however, a rooted Android may not have access to all areas (e.g., Google blocked rooted devices from the Android Movie Market). Later in 2011, the app was removed from the Android marketplace by its maker.

▶ EXPECT SCREENCAST UBIQUITY

With increased prominence of screencasts in all kinds of instructional and library environments, and with more competition in the screencasting

marketplace, screencasting functions may begin to appear in other related programs. The ability in YouTube of adding callouts (shown in Project 5) is one example. TechSmith's screen capture program Snagit can capture video and could make simple screencasts. Will the print screen key on the keyboard someday be replaced with a screencast key?

In libraries, as we continue moving more resources from print to online, screencasting seems likely to become an ever more important tool in also providing our services online. Functional and reliable co-browsing has been sought for years, and some new products are making that easier, but I expect that in asynchronous communication (like e-mail) screenshots and linked screencasts will continue to grow in importance.

RECOMMENDED READING

There are a decent number of articles and a few books out on screencasting, but much of the most interesting discussion is taking place online. Both printed and online resources are included here, as well as some of the sources referenced in the text.

▶ ARTICLES AND BLOG POSTS

Anderson, Rozalynd P., Steven P. Wilson, Felicia Yeh, Betty Phillips, and Mary Briget Livingston. 2008. "Topics and Features of Academic Medical Library Tutorials." *Medical Reference Services Quarterly* 27, no. 4: 406–418. doi:10.1080/02763860802368217.

This article highlights features of screencasts for medical libraries.

Betty, Paul. 2008. "Creation, Management, and Assessment of Library Screencasts: The Regis Libraries Animated Tutorials Project." *Journal of Library Administration* 48, no. 3: 295–315.

Note the assessment part of this article.

———. 2009. "Assessing Homegrown Library Collections: Using Google Analytics to Track Use of Screencasts and Flash-Based Learning Objects." *Journal of Electronic Resources Librarianship* 21, no. 1: 75–92. doi:10.1080/19411260902858631.

This article also addresses assessment techniques.

Carlson, Kathleen. 2009. "Delivering Information to Students 24/7 with Camtasia." *Information Technology and Libraries* 28, no. 3: 154–156.

Carlson describes the process she followed to choose Camtasia Studio for screencasts.

Evans, Darrell J.R. 2011. "Using Embryology Screencasts: A Useful Addition to the Student Learning Experience?" *Anatomical Sciences Education* 4, no. 2: 57–63. doi:10.1002/ase.209.

This nonlibrary article includes techniques for quantitative and qualitative feedback.

Griffis, Patrick. 2009. "Building Pathfinders with Free Screen Capture Tools." *Information Technology and Libraries* 28, no 4: 189–190.

 Griffis describes recommended screencasting techniques using free software.

Hartnett, Eric, and Carole Thompson. 2010. "From Tedious to Timely: Screencasting to Troubleshoot Electronic Resource Issues." *Journal of Electronic Resources Librarianship* 22, no. 3–4: 102–112. doi:10.1080/1941126X.2010.535736.

 This article describes noninstructional uses of screencasts in libraries.

Jacobsen, Mikael. 2011. "Screencasting for an Audience of One." *Library Journal* 136, no. 1: 142.

 This is a great article on how to use screencasts for reference interactions.

Kerns, Stephanie C. 2007. "Technological Tools for Library User Education: One Library's Experience." *Medical Reference Services Quarterly* 26, no. 3: 105–114. doi: 10.1300/J115v26n03_08.

 This overview article evaluates screencasting tools and audience response systems.

MacDonald, Brian S. 2010. "Library Information Services for Distance-Based Customers: An Emerging Mandate for the Digital Age." *Virginia Libraries* 56, no. 2: 6–10. http://scholar.lib.vt.edu/ejournals/VALib/v56_n2/pdf/macdonald.pdf.

 MacDonald describes benefits of screencasting for distance education, primarily using Jing.

McDonald, Molly. 2011. "Demo Girl Portfolio." http://demogirl.com/portfolio/.

 This commercial portfolio of screencasts for online companies comes from a long-time screencaster.

Murley, Diane. 2007. "Tools for Creating Video Tutorials." *Law Library Journal* 99, no. 4: 857–861. http://aallnet.org/main-menu/Publications/llj/LLJ-Archives/Vol-99/pub_llj_v99n04/2007-53.pdf.

 Here is another review of screencasting software from a law library perspective.

Notess, Greg R. 2005. "Casting the Net: Podcasting and Screencasting." *Online* 29, no. 6: 43–45.

 My first column discussing screencasting describes the screencast situation in 2005.

———. 2006. *Teaching Web Search Skills: Techniques and Strategies of Top Trainers.* Medford, NJ: Information Today.

 My book on web search instruction recommends the use of screencasting and evaluates other online library tutorials.

Oehrli, Jo Angela, Julie Piacentine, Amanda Peters, and Benjamin Nanamaker. 2011. "Do Screencasts Really Work? Assessing Student Learning through Instructional Screencasts." *ACRL.* Philadelphia. http://www.goeshow.com/acrl/national/2011/client_uploads/handouts/do_screencasts_work.pdf.

 This detailed analysis supports the effectiveness of screencasts.

Rethlefsen, Melissa L. 2009. "Product Pipeline." *Library Journal* 134, no. 1: S12–S14; 2009. "Screencast Like a Pro." *Library Journal* 134, no. 7: 62–63.

In both articles, the author reviews screencasting software used in libraries.

Reuter, Jewel. 2007. "Screencast.com." *American Biology Teacher* 69, no. 2: 117–118.

A teacher evaluates hosting screencasts at Screencast.com.

Udell, Jon. 2004. "Name That Genre." November 15. http://jonudell.net/udell/2004-11-15-name-that-genre.html; 2004. "Name That Genre: Screencast." November 17. http://jonudell.net/udell/2004-11-17-name-that-genre-screencast.html; 2005. "Secrets of Screencasting." *InfoWorld* 27, no. 20: 34–34.

These three posts are from the early history of screencasting.

Wakimoto, D.K., and A. Soules. 2011. "Evaluating Accessibility Features of Tutorial Creation Software." *Library Hi Tech* 29, no. 1: 122–136. doi:10.1108/07378831111116958.

This study compares software based on accessibility.

Wert, Thaddeus. 2011. "QR Codes and Screencasts." *FracTad's Fractopia* (blog). January 5. http://fractad.wordpress.com/2011/01/05/qr-codes-and-screencasts/.

This teacher posts about using QR Codes to link to his screencasts.

▶ SCREENCASTING OPINION PIECES

Farkas, Meredith. 2010. "What Do They Really Need?" *Information Wants to Be Free* (blog). December 13. http://meredith.wolfwater.com/wordpress/2010/12/13/what-do-they-really-need/.

This post expresses disappointment in some screencasts' effectiveness as a database aid.

Jacobsen, Mick. 2009. "Screencasting to an Audience of One." *Tame the Web* (blog). August 1. http://tametheweb.com/2009/08/01/screencasting-to-an-audience-of-one/.

This post argues for the use of screencasts for reference interactions.

Steeleworthy, Michael. 2009. "Captivate and Screencasting: Measure Twice, Cut Once." *The Zeds: Librarianship, Information Science, etc.* (blog). July 10. http://thezeds.com/2009/07/10/screencasting-adobe-captivate/; 2010. "Screencasting in Libraries: Build a Relationship and Not a Movie." *The Zeds: Librarianship, Information Science, etc.* (blog). November 22. http://thezeds.com/2010/11/22/screencasting-libraries-relationships/.

These posts focus on best practices and how to build relationships.

▶ HOSTING SERVICE HELP AND TRICKS

Bollen, Anton. 2009. "Embedding Jing Videos on WordPress.com." *Jing Blog*, June 23. http://blog.jingproject.com/2009/06/embedding-jing-videos-on-wordp.html.

This article discusses techniques to embed Jing videos at WordPress.com.

Russell, Daniel M. 2011. "Clever Trick to Make YouTube Videos Fill up the Browser." *SearchReSearch* (blog). April 19. http://searchresearch1.blogspot.com/2011/04/clever-trick-to-make-youtube-videos.html.

This blog post describes how to get YouTube video to fill the browser window.

WordPress. 2011. "Support: Writing and Editing Code." http://en.support.wordpress.com/code/.

This help page describes how to manage code on a WordPress.com site.

Yang, Brian. 2010. "Useful YouTube URL Tricks." *TechAirlines* (blog). August 21. http://www.techairlines.com/2010/08/21/useful-youtube-url-tricks/.

This blog post describes linking and embedding techniques for YouTube videos including video URL parameters for video quality, looping, and disabling related videos.

► SOFTWARE

The software listed in Chapter 2 is available at the links listed here, along with help files worth reading and often screencast tutorials for the software as well.

Camtasia Studio	http://www.techsmith.com/camtasia.html
Camtasia:mac	http://www.techsmith.com/camtasia.html
Captivate	http://www.adobe.com/products/captivate.html
Jing	http://www.techsmith.com/jing.html
Screencast-O-Matic	http://www.screencast-o-matic.com/
ScreenCastle	http://screencastle.com/
ScreenFlow	http://www.telestream.net/screen-flow/
Screenr	http://screenr.com/
Webinaria	http://www.webinaria.com/
Wink	http://www.debugmode.com/wink/

► SOFTWARE GUIDANCE

Adobe Captivate Tutorials. 2012. http://www.adobe.com/support/captivate/getting started.html.

This site has current Captivate tutorials.

Camtasia Studio Learning Center. 2012. http://www.techsmith.com/tutorial-camtasia-current.html

This site has current Camtasia Studio tutorials.

Jing Learning Center. 2012. http://www.techsmith.com/tutorial-jing.html.

This site has current Jing tutorials.

Park, Daniel. 2010. *Camtasia Studio 7: The Definitive Guide.* http://www.dappertext .com/csbook.html.

> The downloadable e-book offers the first six chapters for free and includes color screenshots and embedded screencasts.

Screencast.com Help Center. 2012. https://www.screencast.com/help/.

> This site includes screencasts, PDFs, and web tutorials for using Screencast.com.

Screencast-O-Matic Demos. 2012. http://screencast-o-matic.com/channels/cXhI3EVTh.

> This site has Screencast-O-Matic's help videos.

Screenr Help. 2012. http://www.screenr.com/help/.

> The help site for Screenr has frequently asked questions and answers.

Siegel, Kevin. 2010. *Adobe Captivate 5: Beyond the Essentials (for Windows and Macintosh).* Riva, MD: IconLogic; 2010. *Adobe Captivate 5: The Essentials (for Windows and Macintosh).* Riva, MD: IconLogic.

> These two books give in-depth guidance on using Captivate.

Tutorials: Camtasia for Mac. 2012. http://www.techsmith.com/tutorial-camtasia-mac.html.

> This site has current Camtasia for Mac tutorials.

YouTube: Creating or Editing Annotations. 2012. http://www.google.com/support/ youtube/bin/answer.py?answer=92710.

> This YouTube help page describes how to create and edit annotations.

▶ LIBRARY-RELATED SCREENCASTS

In addition to the screencasts created for this book, there are plenty of other library-produced and library-related screencasts available online. Many of them are linked from the companion website (http://www.alatechsource .org/techset/) rather than included here, because they are updated and changed frequently. They are categorized by type of library or screencast with notes about the software and hosting used (when identifiable). Browse the links to access an even wider variety of screencast approaches and techniques than is highlighted in this book. The more you watch, the more ideas you can gain.

BIBLIOGRAPHY

Betty, Paul. 2008. "Creation, Management, and Assessment of Library Screencasts: The Regis Libraries Animated Tutorials Project." *Journal of Library Administration* 48, no. 3: 295–315.

———. 2009. "Assessing Homegrown Library Collections: Using Google Analytics to Track Use of Screencasts and Flash-Based Learning Objects." *Journal of Electronic Resources Librarianship* 21, no. 1: 75–92. doi:10.1080/19411260902858631.

Clark, Ruth Colvin, Frank Nguyen, and John Sweller. 2006. *Efficiency in Learning: Evidence-Based Guidelines to Manage Cognitive Load.* San Francisco: Jossey-Bass.

Farkas, Meredith. 2010. "What Do They Really Need?" *Information Wants to Be Free* (blog), December 13. http://meredith.wolfwater.com/wordpress/2010/12/13/what-do-they-really-need/.

Hartnett, Eric, and Carole Thompson. 2010. "From Tedious to Timely: Screencasting to Troubleshoot Electronic Resource Issues." *Journal of Electronic Resources Librarianship* 22, no. 3–4: 102–112. doi:10.1080/1941126X.2010.535736.

Jacobsen, Mick. 2009. "Screencasting to an Audience of One." *Tame the Web* (blog), August 1. http://tametheweb.com/2009/08/01/screencasting-to-an-audience-of-one/.

Jacobsen, Mikael. 2011. "Screencasting for an Audience of One." *Library Journal* 136, no. 1: 142.

Kerns, Stephanie C. 2007. "Technological Tools for Library User Education: One Library's Experience." *Medical Reference Services Quarterly* 26, no. 3: 105–114. doi:10.1300/J115v26n03_08.

Kirking, Donna, and Doug Nguyen. 2011. "EndNote Web Product Training." Accessed December 7. http://endnote.com/training/tutorials/enweb2/English/EndNote_Web-English/EndNote_Web.asp.

Notess, Greg R. 2005. "Casting the Net: Podcasting and Screencasting." *Online* 29, no. 6: 43–45.

———. 2006. *Teaching Web Search Skills: Techniques and Strategies of Top Trainers.* Medford, NJ: Information Today.

Oehrli, Jo Angela, Julie Piacentine, Amanda Peters, and Benjamin Nanamaker. 2011. "Do Screencasts Really Work? Assessing Student Learning through Instructional

Screencasts." Philadelphia: ACRL. http://www.goeshow.com/acrl/national/ 2011/client_uploads/handouts/do_screencasts_work.pdf.

Park, Daniel. 2010. *Camtasia Studio 7: The Definitive Guide.* http://www.dappertext .com/csbook.html.

Rethlefsen, Melissa L. 2009a. "Product Pipeline." *Library Journal* 134, no. 1: S12–S14.

———. 2009b. "Screencast Like a Pro." *Library Journal* 134, no. 7: 62–63.

Russell, Daniel M. 2011. "Clever Trick to Make YouTube Videos Fill up the Browser." *SearchReSearch* (blog), April 19. http://searchresearch1.blogspot.com/2011/04/ clever-trick-to-make-youtube-videos.html.

Steeleworthy, Michael. 2009. "Captivate and Screencasting: Measure Twice, Cut Once." *The Zeds: Librarianship, Information Science, etc.* (blog), July 10. http:// thezeds.com/2009/07/10/screencasting-adobe-captivate/.

———. 2010. Screencasting in Libraries: Build a Relationship and Not a Movie." *The Zeds: Librarianship, Information Science, etc.* (blog), November 22. http://thezeds .com/2010/11/22/screencasting-libraries-relationships/.

Sweller, John. 2005. "The Redundancy Principle in Multimedia Learning." In *The Cambridge Handbook of Multimedia Learning,* edited by Richard E. Mayer, 159–167. New York: Cambridge University Press.

Udell, Jon. 2004a. "Name That Genre." November 15. http://jonudell.net/udell/ 2004-11-15-name-that-genre.html.

———. 2004b. "Name That Genre: Screencast." November 17. http://jonudell .net/udell/2004-11-17-name-that-genre-screencast.html.

———. 2005. "Secrets of Screencasting." *InfoWorld* 27, no. 20: 34.

Wert, Thaddeus. 2011. "QR Codes and Screencasts." *FracTad's Fractopia* (blog), January 5. http://fractad.wordpress.com/2011/01/05/qr-codes-and-screencasts/.

WordPress. 2011. "Support: Writing and Editing Code." http://en.support.wordpress .com/code/.

Yang, Brian. 2010. "Useful YouTube URL Tricks." *TechAirlines* (blog), August 21. http://www.techairlines.com/2010/08/21/useful-youtube-url-tricks/.

YouTube. 2011. "Creating or Editing Annotations." http://www.google.com/support/ youtube/bin/answer.py?answer=92710.

INDEX

Page numbers followed by the letter "f" indicate figures; those followed by the letter "t" indicate tables.

ABOUT THE AUTHOR

Greg R. Notess is reference team leader and a professor at Montana State University. He has been writing, speaking, and consulting about Internet information resources and search engines since 1991 and about screencasting since 2005. A three-time Information Authorship award winner, he is the "On the Net" and "Search Engine Update" columnist for *ONLINE*. Greg is the author of several books, including *Teaching Web Search Skills: Techniques and Strategies of Top Trainers* and the first three editions of *Government Information on the Internet*.

An internationally known conference speaker on search engines and other Internet topics, Greg has spoken at conferences such as Internet Librarian, Online Information, Web Search University, the Special Libraries Association Annual Conference, and international meetings in London, Tel Aviv, Oslo, Stockholm, Paris, Pretoria, Montreal, Copenhagen, Sydney, Zagreb, and several locations in India. Greg has consulted for several major (and minor) search engines.

On the web, Greg maintains Search Engine Showdown at www.searchengine showdown.com, which reviews, compares, and analyzes web search tools. He also runs the *LibCasting* blog at http://www.notess.com/screencasting, which focuses on screencasting and libraries.